MICHELANGELO'S DAVID

MICHELANGELO'S
DAVID
A Search for Identity

Charles Seymour, Jr.

A. W. Mellon Studies in the Humanities

University of Pittsburgh Press

Publication of this book has been aided by a grant from
the A. W. Mellon Educational and Charitable Trust.

Dedicated to the students
in the Renaissance Seminars in Art History
at the University of Pittsburgh
and Yale University,
1965–66

Preface

IN these days of the novel based on the artist's life, of the motion picture based on the novel, of the television travelog, of intercontinental air travel and accompanying advertising, and finally, of the ponderous, splendidly illustrated volume that puts art history on the coffee table of the North American sitting room— through all such media of communication the towering figure of Michelangelo's colossal marble David of 1501–04 can hardly have escaped general detection. The aim, therefore, of current scholarship and university teaching in connection with the David should not be publication in the original sense of making a thing known. It should be instead almost exactly the opposite: to lighten the dead weight of familiarity; to oppose, if not to correct, a flabby stereotype into which general thinking about so ubiquitous an image could very easily slide.

But rethinking the history and meaning of the David is not easy. In addition to the publicity, there has been a great deal of creative scholarly work on this subject, and often what one may at first mistake for a fresh insight is found to be somewhere in the earlier literature. There are few more certain ways of learning the virtue of humility than to work upon this theme. The study which follows can make little if any claim to originality in factual

detail. If it has merit, it is not in uncovering new data so much as in suggesting a few ways of recombining or simply relooking at the available data.

In the essay which follows two sub-themes emerge. One is deeply imbedded in the historical matrix from which the David *qua* sculpture emerged. It is the problem of finding forms for art to embody great public ideals. In Antiquity, the spiritual being of a whole city might be expressed in a carved figure, the *Tyche*. Something of this type survived the breakdown of the Roman Empire, and in varying modes has come down to us today. On this topic the civic art of Italian Renaissance humanism, particularly in sculpture, has a good deal to say to the mid-twentieth century. The second sub-theme concerns the individual artist's problem in drawing an authentic, personal expression from art designed to carry public and generic meaning. While the first sub-theme might be suggested by some phrase such as "civic imagery," the second is indicated overtly in the sub-title of this volume. A "search for identity" — on several planes of meaning — can be followed from the first extant study-drawing of the marble David to the ultimate stages of the statue's making as it was finished and installed.

There are many reasons why the phrase "search for identity" may strike reverberations in the reader's mind. It is heard a good deal today, often as a password on the fringes of the intellectual world, particularly among the young. Many of these must have firm grounds for feeling disoriented in a world which is still dangerously in a state of crisis. I have thought of them certainly, much as I have thought of the young Michelangelo. But I had two other even more specific and professional reasons for using the

phrase. One centers on the word "search." Perhaps art-historians have tended to concentrate too much on re-search and too little on the original search. They have been dazzled by facets of re-discovery. And they have accordingly written more about results than about process. As their materials they have used acquired facts rather than recovering in so far as may be possible the living experience of the artistic process. With this attitude it is possible to become unwitting prisoners to an idea of history as a mechanical movement forward to a preconceived goal, and committed to an idea of art history that, without our quite knowing how or why, has become so deliberately determined that it is dehumanized. The alternative has dangers also. The process that implies a search, or the search that implies process, can pose historical questions for which no date, no document, no "fact" can provide an answer. My study of Michelangelo's great David will, I am afraid, reveal this to be the case in more than one place. Even so, the risks do not seem so great as to discourage a try nor to outweigh very real advantages in the long run.

My second reason for using the phrase focuses on the word "identity." Much can be learned from the ways in which an artist discovers a sense of his personal identity, and from the ways in which that sense can be expanded to include ideas or entities outside the self. Let me say immediately that I do not intend to use the term in the definition of modern psychology, which I am quite untrained to handle. I have in my mind, rather, an historical usage: the general Renaissance sense of personality. That use of "identity" I have come to see as a process of self-discovery, a constantly repeated attempt at self-definition. In a groping way, Renaissance thought, following in the footsteps of Antiquity, conceived of man

in the guise of sculptor of himself, as his own artist. This role seems to have taught him much about himself and about his relationship with the world. It performed the valuable function of easing certain difficult connections. It provided, for example, a clue to linking some of the basic opposing polarities of life: the individual and the community, reality and the imagined ideal, the past and the present. Indeed, these are the polarities that Michaelangelo had to unify in his marble David.

These two themes implicit in any study of the David — art and public expression and the quest of self in art — were presented in preliminary form in the Mellon Professorship public lecture that I gave in the spring of 1965 at the University of Pittsburgh. To that core I have added a reworking of closely related material offered in the Baldwin Lectures at Oberlin in 1964 and at the Twenty-First International Congress of the History of Art held in the same year at Bonn. Opportunities to present variations and refinements on the two themes were given by lectures at Johns Hopkins and Princeton during the course of the academic year of 1965. My appreciation of the chance to test my work by such exacting standards is very great.

I hope that the selection of documents printed as appendices will prove as illuminating to future students of Renaissance art as they have in my own experience. At present, the only available collection of texts relative to the Cathedral of Florence (and to the David) is Giovanni Poggi's, which came out in 1909 and has become extremely rare. Special gratitude is due both original sponsor, the Kunsthistorisches Institut of Florence, and the original publisher, Bruno Cassirer of Berlin.

xii

This study is published with the assistance of a grant by the A. W. Mellon Educational and Charitable Trust. I should like to express to the Trustees my appreciation of their generous act. I also wish to profer my warmest thanks to the University of Pittsburgh whose hospitality I enjoyed as Visiting Mellon Professor between January and August, 1965.

There now remains the agreeable duty of acknowledging help from individuals. At the University of Pittsburgh Professor William Loerke, Chairman of the Department of Fine Arts, and Professor John Haskins offered valuable advice: to them I am most grateful. The librarian and entire staff of the Henry Clay Frick Fine Arts Library showed me innumerable courtesies, as did Professor Emeritus Walter Hovey and Miss Virginia Lewis when I arrived. I thank particularly the University administrative officers concerned with the Mellon program, especially Vice-Chancellor Charles Peake, Dean Frank Wadsworth, and Mr. Arthur Fedel. For great kindness and encouragement I am deeply indebted to Professor Jean Seznec who was a Visiting Mellon Professor at Pittsburgh while I was there. Particular appreciation goes to a valiant group of students in fine arts at Pittsburgh, above all to Miss Barbara Balzinger, Mrs. Sandra Westbrook, Miss Beatrice Langer, Mr. Howard Collins, Mr. Frederick Cooper, and Mr. David Milgrome. Their names, with those in the next paragraph, are included under the generic reference of the dedication.

Among students in the Renaissance Seminar at Yale who helped with discussions and reports I thank Mrs. Virginia Raguin, Miss Grace Seiberling, Miss Janet Smith, and Mr. Timothy Riggs. My two greatest debts to students are to Mrs. Wendy Stedman, xiii

who provided her translation and suggestions for interpretation of the poem quoted in Chapter 4, and to Mr. Paul Watson, who, faithful to an assignment of several years ago, drafted translations of the appended documents. Another friend and former student in the Renaissance seminar at Yale, Mr. Douglas Lewis, helped in the final assembly of materials for illustration and in reconsidering the program of Sansovino's Giganti of the Palazzo Ducale, in Venice.

My gratitude goes, finally, to Mr. Frederick A. Hetzel, director of the University of Pittsburgh Press, Miss Martha Fry, the assistant editor, and those other members of the staff of the Press responsible for carrying through the innumerable details connected with the design and printing of the volume. And also to Mrs. Lila Calhoun, Mrs. Mig Carlson, and Mrs. Nancy Saiano, who did the type-script in its several revisions.

C. S., JR.

New Haven
Maundy Thursday, 1966

Contents

List of Illustrations

1. Michelangelo. Drawing for bronze David and for arm of marble David, *c.* 1501–04. Louvre, Paris. (Facsimile by Alinari.)

2. Michelangelo. Detail of Figure 1, with scholium and signature: "Davicte cholla fromba / e io chollarcho / Michelagniolo."

3. Greek use of bow-drill represented on antique cameo. British Museum, London. (Photograph by British Museum.)

4. Running-drill in bow form, as was used in ancient Greece, and continued to be used traditionally in Italy. (From Carl Bluemel, *Greek Sculptors at Work,* London: Phaidon Press, 1955.)

5. Nanni di Banco. Quattro Santi Coronati, *c.* 1415. Or San Michele, Florence. (Photograph by Alinari.)

6. Masaccio. Detail of fresco, The Tribute Money, *c.* 1427. Brancacci Chapel, Church of the Carmine, Florence. (Photograph by Alinari.)

7. Donatello. Marble David, intended originally for summit of buttress on North Tribuna of the Duomo, 1408-09. Partially recut and transferred to the Signoria in 1416. Height: approximately life-size. Now in the Bargello. (Photograph by Alinari.)

1

Introduction: "And I with My Bow"

Davicte cholla fromba / e io
chollarcho / Michelagniolo

David with his sling and I
with my bow — Michelangelo

—Written fragment on a sheet of drawings
related to statuary on the David theme, *c.* 1502.

THE autobiography as a literary genre is sometimes offered as proof of the Renaissance artist's drive toward self-revelation. But carefully read, the Quattrocento autobiography of Lorenzo Ghiberti and the later and more famous one of Benvenuto Cellini seem not to record discoveries of self so much as searches for identity, both personal and professional. What is true of Ghiberti and Cellini is true also of Michelangelo, who left, to be sure, no autobiography but, in contrast, a far bulkier legacy of self-directed and self-conscious writing in the form of poems and letters.

Inevitably the trail of personality that runs through those poems and letters leads to the visual art of Michelangelo, in particular his sculpture. And among his sculptures the mind must focus sooner rather than later on the colossal statue of David—carved between 1501 and 1504 by the young Michelangelo, as is well known, from a partly finished statue on the same subject owned by the authorities of Florence Cathedral. The huge David, about 9 Florentine *braccia* or not much under seventeen feet tall, was at first set up on the speakers' platform, or *ringhiera*, near the entrance of the Palazzo Vecchio in Florence. In 1873 it was removed for the sake of preservation to the Accademia delle Belle Arti, where it is now enshrined, and in 1882 a copy was substituted

3

by the Palazzo. That bleak imitation sometimes still catches the admiration of zealous but unalerted tourists, while the original broods in lonely grandeur under its poorly scaled nineteenth-century exedra in the Accademia.

Michelangelo is known to have made drawing studies for his David of 1501–04. The first positive evidence directly connected with what may be called his "search for identity" in his art is found on a precious sheet of study drawings now preserved in Paris, in the Louvre (Fig. 1).[1] The principal study on the *recto* of the sheet is for the pendant right arm of the marble David, the outlines still being felt out, and the final form of the huge, outsized hand as yet unresolved. This very early study for the David is accompanied on the same sheet, since paper at this time was a rare commodity, by a smaller experimental sketch for another David in bronze, commissioned in 1502 for the French military commander in Italy under Charles VIII, Pierre de Rohan, Maréchal de Gié, soon to become the Duc de Nemours.[2]

In relation to the arm study for the marble colossus, the drawing for the small bronze David is freer in style and is to be seen at one side, upside down, and at the lower and upper left, also seen upside down, are two fragments of writing clearly in Michelangelo's own striking hand. On the *verso* of the sheet a further fragment of several lines of verse refers to a cool green shade and a running stream. This Arcadian imagery is accompanied by a drawing of a digging man — apparently a memory of a motif of Adam in the story of Genesis carved by the Quattrocento sculptor, Jacopo della Quercia, for the façade of San Petronio in Bologna. Michelangelo must have pondered it well during his stay in Bologna a few years earlier in 1495–96.

4

The written fragments, or scholia, are set down firmly but apparently hastily, as notes or reminders, or perhaps simply as the reflection of a passing mood — private statements intended only for the artist's eye. Both are believed to have been written at the same time; and since one, as will be seen later, relates to the process of carving the marble David, that time can be placed between 1501 and 1504. Given the fact that they are right-side-up only in relation to the preliminary sketch for the bronze David commissioned in 1502, the date of the inscriptions can be pinpointed in that year, in other words, at a period when the marble David was well begun but still far from complete.

One of the fragments consists of the first words of a famous sonnet by Petrarch:

> *Rotta l'alta colonna...*

These words refer to the loss through death of one of Petrarch's patrons who belonged to the great Roman Colonna family. The words needed to complete the line, presumably well known to Michelangelo, are

> *...e il verde lauro.*

In literal English the complete line would run something like this:

> Broken the tall column and the verdant laurel tree hewed down.[3]

"Lauro" might mean many things to Petrarch, but in Florence around 1500 it could refer only to Lorenzo the Magnificent, de' Medici, Michelangelo's first patron, who had died when only forty-three years old in 1492. To Lorenzo's memory Angelo Poliziano had written a beautiful elegy, set to music by Heinrich

5

Isaac, in which Lorenzo was not mentioned by name but by homophonic reference to "Laurus," the laurel tree, sacred to Apollo and the Muses, by fate too early and too cruelly cut down. Part of Poliziano's elegy, runs as follows:

Laurus impetu fulminis	Lightning has struck
Illa illa iacet subito	our laurel tree,
Laurus omnium celebris	our laurel so dear
Musarum choris	to all the muses,
Nympharum choris.	to the dances of the nymphs.[4]

Michelangelo probably did not complete the Petrarchan line that he had started to inscribe. The sheet of paper might have been cut on the side and so the last part of the line, if written, may have been lost. But it seems more likely that he simply did not feel the need to complete the line — either out of instinctive fear of showing pro-Medicean sentiment in the strongly anti-Medicean Florentine Republic of 1494–1512 or because the first part of the line was enough to serve as a reminder of the whole thought. Whatever his reason, it seems clear that the contemplation represented by this fragment of verse was concerned with serious thoughts about the patronage of artists. Only ten years earlier the great Lorenzo, ruler of Florence before the fall of his house in 1494, had been Michelangelo's patron and protector. In that relationship there was not only inspiration for the artist, but a kind of security which the impersonal patronage of republican institutions around 1500 did not approach. It is possible also that Lorenzo's death was a painful personal loss to the young sculptor. In that case the parallel with Petrarch's earlier relationship to the Colonna would have been extraordinarily close and complete.

6

The Petrarchan fragment on the laurel tree quoted on the Louvre sheet is balanced by an even more intriguing fragment, a scholium which might be the first sketch for the opening of a poem. This fragment, illustrated in Figure 2, reads in Michelangelo's own beautifully formed letters:

> *Davicte cholla fromba*
> *e io chollarcho*
> *Michelagniolo.*

Literally translated, it would run:

> David with his sling
> and I with my bow
> Michelangelo.

As has been frequently pointed out, there is intended a play on the word "bow." The meaning at the literal level is of a bow considered as a weapon. But the secondary meaning surely is not, as was once thought, a reference to a figurative bow of genius drawn against Michelangelo's rival Leonardo; much less, as was advanced in counter-argument, to Cupid's bow; nor even, despite a more recent and more closely argued theory, to the curved portion of a harp frame.[5] The reference is more likely to the sculptor's hand drill. That traditional instrument whose descendant is called in modern Italian *archetto*, was definitely bow-shaped, the metal drill being twirled by means of a taut string as the bow handle was moved rapidly and steadily backward and forward (Figs. 3 and 4).

From Greek Antiquity the bow-like running drill was a major tool for European marble and stone sculptors. It survived the crisis for sculpture in the early Middle Ages and came back

strongly into use, particularly in Italy and Southern France, as effects of light and shade in Late Antique sculpture were studied and emulated; it was a safe method for opening up deep hollows in stone as they became once more desirable. It is noteworthy than an instrument not unlike a crossbow in shape is held by one of Nanni di Banco's workers in stone shown on the relief under his Quattro Santi Coronati for Or San Michele in Florence (*c.* 1415). Almost as much as the chisel and mallet, the bow may be thought of as a symbol of the marble-sculptor's craft in Florence.

The sense of the scholium at a second level of meaning would then become something like this: "David had a slingshot for a weapon in his battle with Goliath. I, Michelangelo, have my sculptor's drill in my battle with another giant." The colossal marble statue Michelangelo was working to finish between 1501 and 1504 had earlier been dubbed "The Giant" (*Il Gigante*) by the Florentines. It is so mentioned several times in contemporary documents; indeed, one reference of August 16, 1501, is not too far removed from the assumed date of the written fragment on the Louvre sheet of drawings.[6] The double parallel between Biblical victor and sculptor, between Philistine enemy and recalcitrant sculptural problem, appears to be inescapable.

Now a question must arise. Is this obvious parallel merely a play on words that caught Michelangelo's passing fancy? Or does it in fact indicate a sincere identification between himself as an artist and the personage of the young Biblical hero?

It is my feeling that Michelangelo did in fact see a meaningful connection between himself at that time and the young David. The Petrarchan fragment on the same sheet appears to be intimately bound into what might be termed Michelangelo's own

8

historical, psychic situation. Though he might regret the passing of the old order of individual, semi-princely patronage which he had valued in his teens, the young sculptor was now in a far more independent position. That position was more precarious, to be sure; but it held out the promise of infinitely greater reward of a professional and moral kind than had been available to any Florentine artist of his generation.

Before we can proceed further into the historical detail that surrounds this question of personal and artistic identity, a certain number of premises must be made clear. Just as the statue was to stand in a particular place and upon a specific base, so the young sculptor of 1501 had his own particular platform for action as an individual and as an artist. It is necessary at this point to sketch the main lines of that position.

There are three principal headings that should be kept in mind. One is the high value that all Renaissance Florentines placed upon their city's traditional independence and beauty; in this respect Michelangelo was no exception. Second, each Florentine had within his city a constant source of visual reference to communal liberty; such visual references were most in evidence in architectural monuments, to be sure, but beginning with the year 1400 they were increasingly present in painting and even more importantly in sculpture. Third, during the Quattrocento the tradition of individual liberty inherited from the High Middle Ages was bolstered by Renaissance humanistic thought and by poetry rescued from ancient Greece and Rome; the second half of the Quattrocento, into which Michelangelo was born and in which he received his first impressions as a boy and youth, saw a tre-

mendous spurt in humanistic learning and influence in all aspects of the arts; the art of sculpture was at this time thought of as a direct parallel to the process of developing the highest good in human nature in general, and in human affairs within the city-state.

Republican traditions in Florence dated from well before the time of Dante, who even in bitterest exile took pride in having been born a Florentine. Michelangelo in his much later time was also first and always a Florentine, never in his own mind an "Italian." A document of 1501 pointedly calls him *civem florentinum*.[7] His ancestry, his family, and his personal ties to individuals within his family were never completely absent from his thoughts, as his correspondence amply testifies. He apparently believed that he descended from the counts of Canossa (where the German emperor had been humbled in the eleventh century). It is clear from sources of every kind that he never could forget his native city, with its bold silhouette strongly defined against the Tuscan Apennines. Nor could he forget its libertarian traditions as boldly preserved in such massive and time-defying architectural monuments as the Duomo, with its Campanile designed by the great Giotto, the Palazzo of the Signoria, with its adjacent Loggia, and the cube-like block of the guild-church Or San Michele, a veritable storehouse of Quattrocento sculpture where a long series of stately statues symbolized the dignity and power of the major trade-guilds.

Our own century is just beginning to recover, in its own modern idiom, sculpture's age-old function as utterance of communal beliefs and goals. It is necessary to make a deliberate effort to recapture what sculpture meant to Florentines in the years that led up to the commissioning of the David of 1501–04.

10

Florentine Renaissance statuary was not intended to be a mere imitation of natural appearance; nor was it intended to function as pure symbol either. Florentine statues did not represent stock versions of virtue. They presented boldly and often with striking originality independent equivalents of human worth — each, as in the case of human beings, like no other; each alive with a suggestion of an *interior* life of its own; and each, in turn, suggestive of a specific human situation, of a moment caught and magnified from human experience. Only specific reference to particular examples can do justice to the character of the statuary of Early Quattrocento Florence.

Previously, in connection with the discussion of the sculptor's bow-drill, mention was made of the Quattro Santi Coronati by Nanni di Banco on Or San Michele (Fig. 5). This group represents the four patron saints of the guild of stone- and wood-workers, among whom were included the sculptors. The figures are grouped within a common niche where they act out with quiet dignity their roles as early Christian martyr-saints awaiting execution on the order of the Roman Emperor, Diocletian. They represent a historical situation in the deep past, but the courage they seem to evince may also have had meaning for Florentines of the Renaissance city-state whose independence was constantly being threatened by larger and more powerful states either singly or in coalition. This statuary therefore combines two levels of meaning. On the one hand it belongs to an imagined world of the heroic past, and on the other it belongs to the present in that it proposes a model for a state of mind at a moment of crisis common to all members of the city-state. Like the images and statues of Rome described by Pliny the Elder, these statues had a part in

11

encouraging a sense of civic dignity and public well-being. In metaphor, they incarnated, insofar as stone can simulate flesh, the commonwealth. Though Christian in imagery, they are Stoic in acceptance of their lot and Epicurean, in the best sense of that much misused term, in their utter calm based on their belief in the rightness of their choice of action.

Such statuary belonged in a general way to Michelangelo's visual heritage as a Florentine. But Nanni's group had even deeper meaning for Michelangelo's ideological growth through its influence on the central group of Masaccio's Tribute-Money Fresco (Fig. 6).[8] The dense structure of Nanni's archaic saints reappears in Masaccio's circle of apostles gathered around the central figure of Christ, Whose gesture pointing to His right is echoed by that of St. Peter exactly in the same way that a pointing gesture had been used as a unifying element of form in Nanni's statuary group. We know that as an apprentice in Ghirlandaio's *bottega* just prior to 1490, Michelangelo spent hours copying Masaccio's strongly individualized and sculpturally organized figures. He not only absorbed habits of seeing and constructing form in this way, but he could hardly have failed, also, to take in the deeper meaning underlying Masaccio's Tribute-Money image: not, as is sometimes supposed, that one should "render unto Caesar things that are Caesar's," but that all free "sons of the King" (that is, of Christ) owe a tax to the community to ensure their common freedom.[9] Freedom and equality of all men, according to ancient Epicurean doctrine, is in the "natural" order of things. The naturalistic environment of the painting's action — the firm platform of the earth, the illusion of breathable atmosphere surrounding the powerful figures, the deep space leading toward

the image of the Prato Magno looming over the Arno Valley near Florence—enhances its philosophical message. Some decades before Michelangelo's birth, but well within his experience as an artist, nature and art had been combined to express a belief in justice and equal rights for all citizens and in the duty of the stronger to help the weaker.[10]

The continuity of the ideal of citizens' freedom under law from the time of the Brancacci fresco (in or about 1427) to 1501, though weakened under Medici rule, was nonetheless unbroken. Probably the single most prominent freedom symbol for that period was the shepherd slayer of Goliath and savior of his people, the youthful David with his sling. Indeed in sculpture that image occurred even before 1427; in 1416 Donatello had recut an earlier, prophet-type statue of David in order to include the sling (instead of the medieval attribute of a scroll) and sold it to the civic governmental authorities, the Signoria, as a symbol of civic liberties for their palace, or city hall (Fig. 7).[11] That statue, as we shall soon see, was a lineal predecessor of the David of 1501–04.

However, between what may be called the early eclectic phase—naturalistic, libertarian, Epicurean—of Quattrocento thought and Michelangelo's carving of the David of 1501–04, there occurred a notable change of intellectual climate of which we must take some account.[12] This was an intensification of interest in classical Antiquity and with it a revival of Platonism as opposed to Epicureanism spurred by the recovery of Neoplatonic texts and commentaries. A new note of mysticism and other-worldly idealism crept into Florentine thinking. It found its center, as is well known, in the Medicean circle. Its chief exponents were Marsilio Ficino, Cristoforo Landino and Giovanni Pico della

13

Mirandola—all supported by Medici patronage and all inspired by the ideal of reconciling traditional Christianity with the wisdom of the Socratics and the more arcane elements of the Hebrew tradition and of the ancient Near East.

At first glance, it would appear that Florentine Neoplatonism could do little else but erode, perhaps disastrously, the basis for the traditional art of Masaccio and Donatello. But it seems evident today that whereas a new subtlety in later Quattrocento art was bought only at the expense of the robust clarity and power of the early decades, Neoplatonism did not by any means destroy the meaningful relation of sculpture to life and to the ideals of a higher humanity. Admittedly, to attempt the construction of a neat and systematic equation between philosophical theory and sculptural practice in Florence in the years surrounding 1500 would be foolish. The evidence in writing is not particularly abundant or clear, and Michelangelo's known experience is no exception to this rule. His writings around 1500 were probably sparsely scattered and what is left for us to read does not help very much to bridge the gap between intellectual theory and artistic practice at that crucial time.

Nonetheless, as a practicing artist with a solid Florentine background, he could hardly have been untouched by the liberal tradition of Florentine humanism that was born near the turn of the century, around 1400. The association of sculpture as an art with the concept of human perfectibility was in common currency at the court of Lorenzo the Magnificent. Plato himself, of course, had used sculpture as a vivid metaphor in discussing the good in human character,[13] and the Late Antique Neoplatonist philosopher Plotinus, in a passage that is characteristic of the Neoplatonic

use of extended metaphor in explication of mystical doctrine, had strikingly employed the notion of the sculptor's technique to illuminate his idea of the inward contemplation of the soul. "How can one see the beauty of a good soul?" Plotinus asks and then answers:

Withdraw into yourself and look. If you do not see beauty within you, do as does the sculptor of a statue that is to be beautiful; he cuts away here, he smooths it there, he makes this line lighter, this one purer, until he disengages beautiful lineaments in the marble. Do you do this too . . .[14]

The translation of Plotinus' Greek ideas into Latin by Ficino was published in 1492, the year Lorenzo the Magnificent died. The young Michelangelo was still under Medici tutelage and must have been in close touch from time to time with the Neoplatonic group that had as its chief spirit Ficino himself.[15] No one can assert today just how much, or how little, of the endless discussions within the Medici circle on the essence of human virtue were absorbed by the quick mind of the sixteen- to seventeen-year-old Michelangelo. Nor can one generalize too far without evident peril on what specific lessons or inspiration he might have derived from direct contact with the heady doctrines of Florentine Neoplatonism at its source. Usually Platonism is interpreted as something of an enemy to visual art in that Plato himself is believed to have thought of art mainly as a craft and merely "an imitation of an imitation" of reality. It would be much fairer to say that Florentine Neoplatonism did not oppose art so much as it placed emphasis on its inner being, on a suggestion of spirit *(animus)*, rather than on naturalism of appearances. This view might well have had a deep and lasting influence on Michel-

15

angelo's thought. It corresponds to his long-lived idea that the sculptural image was to be found *within* the block just as beauty of soul is to be found ultimately *within* the physical human being. The basic esthetic attitude of Michelangelo as a sculptor can hardly be called strictly Platonic, but it seems to have had a deep and meaningful relation to doctrines of Plotinus. And these could have first come to him through his early connection with the Medici, in the very heart of Florence and at a time when his mind was most apt to receive and conserve impressions of this sort.

It is possible now, with this historical background in mind, to return to the Louvre drawing sheet and to the scholium it presents. The figure of the bow as artistic weapon now may be seen as enlarged with ethical as well as esthetic meaning. The similarity of the advice of Plotinus in search of beauty of soul with the identification of the sculptor in search of beauty in art is interesting: "Withdraw into yourself and look...Do as does the sculptor of a statue..."

It would seem that in 1502 Michelangelo saw himself as a new David, battling with a giant, on at least two planes of meaning. The first was in part technical and concerned art rather than military science. The second was in part sociological, in part philosophical. It concerned not only the young sculptor's background as a Florentine citizen, but the remains of libertarian humanism that had some time before him already found direct expression in public Florentine art; and it included the impact of Neoplatonic idealism of more recent vintage from the Medici circle.

In the reverie that the written scholium on the Louvre sheet of drawings records, Michelangelo evidently felt himself committed to the final and critical stage of a long and difficult struggle. He faced in 1502–03 the modeling and casting of the small bronze David for the Maréchal de Gié, to be sure. But his immediate challenge and dominant task still had to be the finishing of the first colossally scaled marble figure in all of Florentine art. Though not so indicated in Vasari's well-known description of the David's background and origins, the huge figure was in fact intended to be one of a series of twelve prophets to go on the buttresses of the so-called Tribuna—the eastern portion of the Duomo surrounding the cupola. This Tribuna Prophet-series had been planned for nearly a century and grappled with by a number of Michelangelo's predecessors among the Florentine sculptors. In typical Florentine, one might almost say Dantean, tenacity the program had never been wholly abandoned. The details of that program can be reconstructed from the surviving documents in the Cathedral of Florence archives. These documents, rather than the racier version of the story retailed by Vasari, will be the basis for the narrative of events leading up to Michelangelo's commission for the David of 1501–04 contained in the next chapter.

2

Prehistory and Genesis: The "White Colossus"

Item deliberaverunt quod ille homo magnus et albus qui positus est supra ecclesiam sancte Reparate albetur de giesso.

Item. It was decided that the white colossus which has been put into position on the church of Santa Reparata should be coated with whiting.

—Minutes from the meeting of the overseers of the Florentine Duomo (Santa Reparata) on February 9, 1412.

THE story of Michelangelo's David is one of the best known in all art history, a close rival to the account of the competition for the commission of the Florentine Baptistery doors which took place exactly a century earlier. It is perhaps accurate to say that this history began when a huge block of Carrara marble, owned by the overseers *(Operai)* of the Florentine Duomo, was handed over to the twenty-five-year-old sculptor to finish in the summer of 1501. But it is not wholly truthful.

The marble block had been worked on as a statue in the middle of the Quattrocento, but the sculptor had been clumsy and the start abortive, *male abbozzatum* as the contract with Michelangelo stated—"faultily roughed out." And so, as every first-year student knows, the block had languished in the courtyard of the Cathedral workshop for thirty-five years, a monstrous failure, until it was rescued and turned into a masterpiece by the young genius. When finished it was placed in front of the Palace of the Signoria as a symbol: just as the Biblical David had "defended his people and governed it with justice, so he who would govern this city should valiantly defend it and justly rule it."

The quotation is from Vasari's *Life* of Michelangelo, originally published in 1550 and revised in 1568, after Michelangelo's death,

21

with relatively few changes in the text dealing with material up to 1550. Both editions were printed in Florence by printing houses licensed by the Duke of Tuscany, then Cosimo I de' Medici, and both were dedicated to that ruler.[2] Vasari's *Life* has been generally used as the basis for the story of the genesis of the David. Its rapid tempo and vivid sense of detail has commended it to most readers, and, indeed, in some respects the David owes its enormous fame to Vasari. But such popularity derived from Vasari's account has been purchased dearly at the expense of facts which, when assembled, make a different but no less fascinating narrative.

Before looking behind the façade of Vasari's version of what happened, let us take account of what he wrote.[3] He began with Michelangelo's return to Florence at the urging of "friends" who did not

want that block of marble spoiled which Piero Soderini, then gon-faloniere for life in the city, had frequently proposed to give to Leonardo da Vinci and then to Andrea Contucci [Sansovino], an excellent sculptor who wanted it. Michelangelo on returning tried to obtain it although it was difficult to extract a whole [standing] figure from it without adding pieces and no other man except himself would have had the courage to make the attempt, but he had wanted it for many years and [so] on returning to Florence he made every effort to get it . . .

The implied competition between Leonardo, Sansovino, and Michelangelo for the marble block is, as far as we know, apocryphal. It smacks too much of the competitive struggle between Ghiberti and Brunelleschi to obtain the commission for the Baptistery doors in 1401–04, to warrant credence, though there is evidence that the events of 1401 were in the minds of Florentines

22

a century later, as we shall soon discover. Also, Vasari is clearly wrong in his attribution to Soderini of the role of patron. Piero Soderini was not made Gonfalonier-for-life or head of state in the Florentine Republic until late in 1502, nearly a year and a half after the David had been commissioned of Michelangelo in August 1501. It is, however, probably true, as Vasari states, that the technical problem of carving a well-proportioned figure in the full round from the previously roughed out block was great. And the alternative mentioned by Vasari of adding supplementary bits of marble, doweled into the original block, was in fact likely to be esthetically and ethically distasteful to Michelangelo, as we learn from the writings of the Florentine academician Benedetto Varchi.[4] In describing the situation Michelangelo faced, Vasari went on to say of the block that it was

nine braccia [approximately seventeen feet] high, and unfortunately a certain Simone da Fiesole had begun a "giant" from it, very badly executed, hacked out [too much] between the legs so that the over-seers of S. Maria del Fiore had abandoned it without wishing to have it finished and it had rested so for many years. Michelangelo examined it afresh and decided it could be carved into something new while following the pose sketched out by Simone, and he decided to ask the operai and Soderini for it. They gave it to him as a useless thing, thinking that anything he might do would be better than its present useless condition...

The picture given here by Vasari has an unjustified ring of authenticity largely because of the precision, if not the strictest accuracy, of the measurement of the block of marble. But it was known at least as early as 1840 that there had been no "Simone da Fiesole" involved; instead a contract had been let out to

Agostino di Duccio in 1464. Vasari, it will be noticed, fudges the incident and then returns once again to the theme of the "useless" block and the young artist's unilateral desire to make something out of it. Just how badly the block had been spoiled is of course today impossible to say; the evidence disappeared with the marble-chips splintered off by Michelangelo's point and chisel. Even the bit of the top of the block that Michelangelo left uncarved at the crown of the David's head as proof he had used the entire block, was removed in a "cleaning" of the statue in the eighteenth century. Nonetheless, the block could hardly have been so badly flawed as to preclude hope for its eventual use. In 1476 the Operai, contrary to the impression given by Vasari, attempted to sign up the sculptor Antonio Rossellino to finish the work begun by Agostino;[5] the attempt came to nothing, to be sure, but one should be wary of the Vasarian propaganda of total disenchantment in the block until Michelangelo's "offer" of his services and talent.

Documents of the Duomo archives, of which a relevant selection is reprinted in the back of this volume (Appendix II-A), make it clear that the commissioning of the David had nothing to do with Soderini's role as a patron, nor with the surrender of the weary Operai to the call of youthful genius. The contract of August 16, 1501, entrusted the block to the artist in the usual prosaic terminology of Quattrocento agreements of the same type. The artist was to be paid according to a time schedule and a standard of quality was evidently set.[6] The contracting party as patron was not Soderini but the Operai, in accordance with firmly held tradition. The Operai were jointly cited with the consuls of the Wool Guild (Arte della Lana), which for decades had provided

funds and determined policy in connection with the Duomo's programs of sculpture (Appendix II-A, p. 137). It is evident that (Michelangelo did not magnanimously offer his genius as if he were already a Cinquecento giant; instead it would seem that, like a Quattrocento artist-craftsman, he was hired to do a job.)

The remainder of Vasari's account contributes several details such as the device used by Giuliano and Antonio da San Gallo to hoist the statue onto the framework for moving it to the Piazza della Signoria (though no mention is made of the other artists, including Cronaca, who are known to have worked with Giuliano on this task); and the anecdote whereby the sculptor fooled Soderini into believing he had made a correction on the nose. It contains, finally, extravagant praise, period-bound by Vasari's esthetic views of around 1550 and his own teleology of art history; (Vasari made the sculptor of the David the peak of artistic endeavor of all times.) Vasari speaks of the David as a "revival of a dead thing" and therefore as "a veritable miracle" and asserts unblushingly that it

certainly bears the palm among all modern and ancient works, whether Greek or Roman, and the Marforio of Rome, the Tiber and Nile of the Belvedere and the colossal statues of Montecavallo do not compare with it in measure and beauty. The legs are finely turned, the slender flanks divine, and the graceful pose unequalled, while such feet, hands and head have never been excelled. After seeing this no one need wish to look at any other sculpture or the work of any other artist.

He ends with the statements that Michelangelo was paid by Soderini, which is false; and that the statue was set up in 1504, which is true as far as it goes, but in no way suggests the lengthy and historically important debate that preceded the decision

on the statue's placement. For its purposes, which were evidently more propagandistic than historical and more eulogistic than analytic, Vasari's account has a real literary value and without a doubt validity for the artistic politics of the period of its writing. But it is nonetheless a minor masterpiece of special pleading based on an ingenious mingling of fact with half-truths and innuendo.

Behind Vasari's camouflage lies the history of a century-long effort to place, high around the east end of the Duomo, on the tops of the buttresses supporting the three Tribuna-apses, a monumental series of twelve prophets. During the course of the fifteenth century, successive attempts had been made to carry forward this program. One of these figures was to represent David—evidently not as King but, in the Florentine iconographic tradition of the Quattrocento, as a lowly shepherd boy who, armed with divine protection and a sling, became the defender of his people. It is not sufficiently recognized that Michelangelo's David, though it emerged in lonely grandeur in 1504 as a single figure, was begun in 1464 as part of this series and continued so until 1501. The David of 1501–04, indeed, represents the fourth attempt to carve for the largest church of the city-state a figure on the theme of civic dignity and freedom. It is no wonder that the young Michelangelo, on his return from Rome in 1501, was eager to take up the double challenge of the huge block of Carrara marble, then lying in the Cathedral courtyard and bearing the marks of earlier failure, and of the unfinished Prophet-program, so prominently and closely woven into the fabric of civic life in Quattrocento Florence.

[The Prophet-program had had a long and artistically promi-
nent history of its own. The chances are strong that the origins of
the program went back to Dante's period and possibly to ideas
developed by Giotto himself before his death in 1337. Giotto had
suggested a similar program in one of his paintings. The *parti*
of white marble statuary *all'antica* occurs at roof level in the repre-
sentation of Herod's palace in the Peruzzi Chapel frescoes in
Santa Croce.[7] It is but a short step from this imaginative recreation
of Antiquity in Santa Croce to the adaptation of the idea that is to
be found in the mid-fourteenth century picture of one of the early
Duomo models in the Spanish Chapel (Fig. 9). These prophets
bearing scrolls are placed prominently as statuary high up on the
cathedral's exterior buttresses. Continuity from this Giottesque
heritage, though slow in tempo, was apparently unbroken. It
carried, it would seem, to the commissions for the two white
marble Prophets by Nanni di Banco and Donatello of 1408. These
two statues bear a humanist stamp, derived in part from Giotto
and Arnolfo, but they inherit a legacy also from the generation of
Florentine sculptors born toward 1370 who had looked once again
at the art of Antiquity with fresh eyes.]

The well-known program of "Giants" for the exterior of the
Milanese Duomo also may have influenced the decision at the
beginning of the Quattrocento to get on rapidly with the Floren-
tine Tribuna Prophets.[8] But the Milanese Giants, though interest-
ing historically for the concept of colossal scale in sculpture, were
a far cry from the scale, character, and visual function of the two
Florentine Duomo Prophets that had been completed by Nanni
and Donatello in 1408. In Milan the Giants were essentially semi-
monstrous prisoners forced into poses of constrained atlantes

27

and condemned to the visual function of supporting gargoyles in a northern Gothic environment of forms. In Florence, though the figures were obviously influenced by the International Style of Late Gothic, they were to stand aloof and free. The David by Donatello, a symbol of independence, was already independent in form (Fig. 7). The rhythms of what one must still believe to be Nanni's pendant Prophet of exactly the same date (1408–09) suggest an inner vitality that subtly works free from the restrictive pressures of environment (Fig. 8); subject and form merge. But like Donatello's David, it was never put into the place for which it was evidently carved; today it is virtually lost in a skied position in a high niche in the south aisle of the nave of the Cathedral.

It is obvious today that these two early Renaissance Tuscan Prophets were victims of a conflict between radically differing concepts of sculptural scale. Carved at normal human scale, they were simply too small to make their intended visual effect on the enormous building. Thus, as a corrective, the colossal scale for the Prophets was introduced in 1410, with the commission for Donatello's terracotta Joshua for the North Tribuna. From all available evidence, that huge figure, several times the size of life, stood in its place on the Tribuna until well into the seventeenth century (Figs. 10 and 11). The type of this figure is suggested by a recently published drawing by the seventeenth-century French engraver, Israel Silvestre, who made the drawing on a trip to Italy (Fig. 11).[9] The Joshua by Donatello appears to have been partially draped in a mantle and evidently was not provided with armor. As a figure symbolizing civic *virtù* and freedom it incorporated the key words from the opening of the Book of Joshua:

Be strong and of a good courage, for unto this people shalt thou divide for an inheritance the land which I swore unto their fathers to give them.[10]

Donatello's terracotta statue of Joshua has not been sufficiently mentioned in art-historical manuals. It was the first genuine colossus in Florence according to the Renaissance standard — a height at least three times that of nature — and its material also deserves attention. A marble figure three times life-size would result in a weight so great that the engineering problem alone, that of devising means to lift it up and hold it securely in place on a buttress of the Cathedral, would be as formidable as the problem of carving the detail at so unusual a scale. Terracotta as a material is so much lighter than marble, especially if the figure were modeled hollow, that its use must have appeared quite naturally as a solution to the problem, particularly if a metal strut were used as a brace against the wind, as was actually done in the case of the Joshua. Terracotta could also be painted, as indeed the Joshua was, in order to preserve the relatively friable surface against the weather. Unfortunately the paint-surface of the Joshua was far from permanent, as the documents indicate; repeated coatings were needed to keep the surface fresh and intact. Out of such difficulties may well have come a little later the della Robbia invention of a glazed surface for terracotta statuary — as in the Joshua, solid white in color.

The use of white is noteworthy. Most Quattrocento terracottas for interior exhibition continued the medieval custom of polychromy — contrasting, as in paintings, bright reds with blues, greens, and gilt. The use of solid white points toward a revival 29

of the customs and theory of Roman Antiquity in which marble
was prominently featured. Florentine humanistic interest in the
lore and theory of ancient art best accounts for the use of whiting
as a surface coat for the Joshua: at a distance, high above the
spectator's eye, the figure would give the impression of being
made of white marble. Thus, Giotto's proto-humanistic depiction
(in the Peruzzi Chapel fresco mentioned earlier) of marble statuary
on Herod's palace found an echo in reality. Antique insistence on
the human image as the subject par excellence of statuary found
another echo in the Joshua. It was very early, in 1412, characterized
in the Cathedral documents as *homo magnus et albus:* the "White
Colossus." Notice that the Latin *gigans,* or "giant," was not used
at this time. The overtones of evil or monstrosity in "giant" were
avoided by the use of *homo,* "man," even at the expense of some
awkwardness in phraseology. As late as 1501, when the program
was under discussion just before Michelangelo took over the un-
finished marble figure which Agostino di Duccio had begun to
carve, it was called, in quite evidently an echo of the Duomo
document of 1412, the "man" of marble, *homo ex marmore* (docu-
ment for July 2, 1501).

The humanist flavor in the colossal Joshua goes far to explain
the proposal in 1415 to add a Hercules to the Duomo Prophet-
series. Though hardly in the class of prophet, Hercules, as a
symbol of fortitude and freedom, could be considered a direct
parallel to the Old Testament Joshua. Also, he had appeared
in small scale immediately below the Tribuna in the Porta della
Mandorla even before 1400 (Fig. 12) and earlier still had enjoyed a
Florentine civic connection as an emblem on the medieval city's
official seal.[11]

The technical problem of finding a light yet durable material for the Prophet-program still continued to plague the Operai only three years after the completion of the Joshua. The Duomo documents describe a model (now lost) of a Hercules prepared in 1415 by Donatello and Brunelleschi that called for gilded metal plates over a core of building-stone *(macigno)*. The choice of stone as interior stiffening and ballast in high winds for the relatively light figure is most interesting. It appears to have been an experimental reconstruction of no less a colussus than that of ancient Rhodes. Pliny's description of the fallen Rhodian colossus, available to the Florentines of the Quattrocento, makes prominent mention of stones that were used in the hollow interior of the huge metal figure as a stabilizing device: "... spectantur intus magnae molis saxa quorum pondere stabilaverat."[12]

The Hercules of 1415 for the Duomo series never got beyond the stage of the model, but the general idea of a plated technique was later used for Donatello's St. Louis of Toulouse on Or San Michele. Though somewhat damaged, the Hercules model was still in existence as late as 1449, when the Signoria showed momentary interest in acquiring it, probably as a parallel to the David of 1408–09 by Donatello.[13] Here is evidence of a continuing close association on the symbolic plane between the subjects of David and Hercules (as well as with Joshua) in public art in Florence up to roughly 1450.

The historical path to the marble colossus finished by Michelangelo leads now through one extremely problematic figure. It is a David in marble commissioned of Donatello in 1412.[14] This successor to the David of 1408–09 (David I) may be called the David II. The documentary evidence on this piece is most difficult

to sift. The records for the David II coincide in time with those for two other Donatello commissions for the Duomo, the terracotta Joshua already discussed and a seated St. John in marble for the façade. References to advances to the sculptor for each work overlap bewilderingly in the deliberations of the overseers. It does seem possible, nevertheless, to sort out the accounting for each of the three pieces; the hardy reader may follow the reasoning in Appendix I.

In 1411 the Joshua in terracotta had already been painted white, and in 1412 it was given a second coat, this time of whiting *(gesso)*. To the modern reader a problem of surface is at once apparent. It would seem that the authorities were once more being attracted to marble for a durable white surface. From the documents, it seems reasonably clear that the marble David II was an unusually short-lived attempt to solve the problem of the Prophet-series. The block was ordered, the design drawn up, but the statue appears to have been abandoned in 1415.

When the idea of metal plates, suggested for the Hercules in 1415, failed to be adopted as another alternative to marble as a material for the series, the whole project's momentum faltered. But discouragement came only after a spurt of extraordinarily concentrated effort. Within the span of only ten years the Duomo authorities had made four separate attempts to solve the visual and structural problems inherent in the program of *Profete* designed for the buttress-summits of the apses. Although two of these attempts clearly did not involve a colossal scale, a third very probably did; there is no doubt that the fourth attempt was at colossal scale.

Inspired by Antiquity, humanist art-theory of the Quattrocento was fully in harmony with this attempt to make use of the colossal scale in sculpture. Available texts from Antiquity, such as sizable passages of Pliny the Elder's *Natural History,* detailed glamorous accounts of colossi. Ancient Rome alone boasted several colossal figures: the original terracotta Jupiter of the Capitoline, Etruscan in origin, later exchanged for the bronze figure cast from the spoils of armor taken from the defeated Samnites; the gilded bronze Sun-Colossus, originally given the features of the Emperor Nero, the head and one hand of which survived destruction in the early Middle Ages and could be admired by touring pilgrims in front of the Lateran palace of the pope; the marble horse-tamers, called the Dioscuri, of the Quirinal, or of "Montecavallo," that Vasari was later to mention in comparison with Michelangelo's David. Such relics of the grandeur of the Roman past were familiar to European travelers and pilgrims for centuries before 1500; they were counted among the "marvels" *(mirabilia)* and a guide book literature around them grew up as early as the twelfth century. The examples listed there were of bronze or marble, but the Renaissance use of terracotta for colossal figures at great height on a large building was pointedly reinforced by Antique precedent. As Pliny the Elder wrote,

... at Rome and in the municipal towns [older Etruscan centers] there are many temples whose roofs are still adorned with terracotta figures, remarkable for their modeling and artistic quality as well as their durability ... more deserving of respect than gold ... [15]

Pliny's reference to the superiority of a fine design in a work 33

of art executed in lowly terracotta over an indifferent design executed in gold would have found immediate favor in the eyes of his Florentine readers of the fifteenth century, and indeed it must probably be counted among the factors which encouraged the bold commissioning of Donatello's colossal terracotta Joshua in 1410. It appears that there was in Florence in the first half of the fifteenth century nothing less than a mystique of the colossus, largely revived by humanistic admiration of the Antique. In 1435–36, the greatest theoretician of the fifteenth century, Leone Battista Alberti, paraphrased in his treatise on painting Pliny's preference for worth of design over worth of materials in art. Alberti also seems to have reflected a general admiration for the colossal mode when he wrote that in contrast to the capability of the sculptor to produce a colossus, the painter could reach an even greater achievement in being able to present a dramatic scene in natural colors (in Italian, *istoria*); even more to be admired than a colossus, Alberti stated, was the noblest achievement of the painter, an *istoria*.[16] In his slightly earlier treatise on sculpture, the *De Statua* of 1430–35, Alberti was concerned with the separate designing and fitting together of parts of marble statues, thereby implying a colossal scale since in life-size statuary, normal for the Quattrocento, such practice would be quite unnecessary. Only a few years later, in 1464, as we shall shortly see, the idea of constructing a colossal marble for the Tribuna-program was considered by the authorities of the Duomo in Florence. The colossi of Antiquity were listed in his *Commentaries* by that avid reader of Pliny the Elder, Lorenzo Ghiberti.[17] There can be hardly the shadow of a doubt, even in the minds of the most skeptical, that

in Florentine theory the colossal mode in public sculpture, with emphasis on civic and heroic meanings and paralleling consciously recorded practice in Antiquity, had become, by 1450, firmly entrenched.

To understand this point is to understand in large measure how it was possible in 1463 to reactivate the Duomo Prophet-program and once again, after such inconclusive results if not partial failure, to return to the problem of creating statuary at a colossal scale for the Tribuna buttresses. The occasion for this renewed attempt has never been at all clear to historians of Florentine art until quite recently. In 1463, the Florentine sculptor Agostino di Duccio had just been called back to his native city from Bologna where he had been put in charge of finishing the façade of the great basilica of San Petronio begun some years earlier by Jacopo della Quercia. Once in Florence, even though he had never shown marked ability except as an architectural relief-sculptor, Agostino was inexplicably given the commission to proceed with the program of colossal figures for the Prophet-program. Why and how had so rash, according to our modern view, so unexpected a course of action been determined? How can we explain the part of Agostino?

The answer to these questions appears to be in circumstances centering on Donatello's last years. He had left Florence completely for northern Italy in the decade 1443–53. He then returned to Florence for a few years, migrated to nearby Siena temporarily, and finally, in 1461 he was once more in Florence where he was to remain until his death in 1466. One of the reasons traditionally given for his final return to Florence was the commission from 35

Cosimo the Elder, de' Medici, for the so-called Pulpits for San Lorenzo. Another reason, for which there was a tradition in existence until 1525, may have been the commission for the Prophet-program of the Duomo.[18] According to this tradition, it was not Agostino di Duccio who was primarily entrusted with the continuation of the Duomo Prophet-program in the early 1460's, but Donatello, the sculptor who had been so prominent in the early phases of the program up to 1415. The mid-Quattrocento continuation of the program appears to have been at first based on repeating the type and technique of the huge Joshua figure commissioned in 1410. It would have been natural for the Duomo Operai to have selected Donatello for the task of completing a series which he had begun and equally understandable that Donatello would have enjoyed the prospect of finishing what he had started. Immensely famous by this time, when he was in his eightieth year, perhaps even older, Donatello took up the challenge. We have newly discovered evidence of this in a memoir or *ricordo* of his physician and personal friend, dated 1466. There could hardly be a more trustworthy source.[19]

If we accept, as I believe we must, the idea that the venerable Donatello did in fact return from Siena to Florence to complete the libertarian program of statuary begun in his relatively youthful period, much that has been vague and puzzling comes into focus. For one thing the appointment of Agostino di Duccio in 1463 does not appear so curious as it once did. Donatello, already approaching his death in old age, would have needed an experienced assistant to act as his amanuensis in carrying out the strenuous physical work of modeling or carving at a colossal

scale. Agostino had been trained on the Duomo premises and from the evidence of style he seems to have assisted Donatello in at least one very important commission, the so-called Cantoria of the Duomo choir, in the 1430's. The choice of Agostino as executant of the ideas of the old Donatello makes sense. By 1463 Agostino had assumed the heavy responsibility of carrying out in terracotta a colossal figure of a Hercules, a subject probably determined by the model of the statue made by Donatello with Brunelleschi in 1415. The documentation makes clear that the figure, like the earlier Joshua, was to have been made of several parts joined together. It was completed in 1464, paid for, apparently fully approved, and possibly set up on the south Tribuna of the Duomo.[20]

The success of the terracotta Hercules led without delay, in 1464, to the commissioning of another colossus, this time a David, and of marble rather than of terracotta. Agostino was sent off to Carrara to select the marble needed for the figure. It was not originally to have been carved from a single block (see Appendix II-A, p. 129). Caution in assigning the commission for execution was still reflected in the stipulation that the David was to be carved in four pieces.

Then, mysteriously, a decision to make the statue of one piece of marble was taken; and, just as mysteriously, late in 1466, the contract with Agostino was broken off. The two documents of that year do not in the least suggest, as legend would have us believe, that Agostino had botched the piece (see Appendix II-A, pp. 131-35). There is no hint of failure or of official recrimination. It would seem instead that a new factor quite unexpectedly 37

had entered the situation and that the Operai became eager to break off the contract honorably and cut their losses. Why?

The most plausible reason why work on the David by Agostino di Duccio was suddenly discontinued in 1466 is the death of the directing sculptor. The contract with the executant was ended quite amicably on December 30, 1466; it is probably no coincidence that only a few days earlier in the same month Donatello had died. With his disappearance the impetus for the program must have lost its appeal for the Operai. Ten years later an effort was made to interest Antonio Rossellino in completing the statue, but nothing appears to have come of that effort.

The incomplete marble David whose beginning was so inauspicious, then drops out of sight until July and August, 1501. The political crisis caused by Cesare Borgia's invasion of Florentine territory and a revival of Florentine patriotic fervor once more put pressure on ways and means of asserting traditional republican virtue in art. The Arte della Lana (chief patron of the Duomo) just at this time reactivated the program of Prophets for the Duomo. Their choice of artist fell, for reasons that are quite unrecorded, on the young Michelangelo. Their action (not that of Soderini as Vasari states) brought Michelangelo the responsibility of making the giant David a reality of finished sculpture. The documents of July 2 and August 16, 1501, leave no doubt that the David then intended for the Tribuna program was more than a coarse *figura digrossata*: it had legs to stand on *(in pedes stare)* and a breast in which, or on which, was a form described as a *nodus* which Michelangelo struck off dramatically on September 13.[21]

38 It was called both a "man" and a "giant" *(hominem vocato Gigante),*

and thus combined two of the humanistic descriptive terms implied in the striking, earlier, Quattrocento phrase: the "White Colossus," *homo magnus et albus.*

✔ We view the eve of Michelangelo's actual carving of his giant from quite a different vantage point than that offered by Vasari, propelled as he was by his worship of Michelangelo as a "modern," that is to say, a sixteenth-century artist. The David of 1501–04 stands at the brink of the sixteenth century, not only by date but in most aspects of its style and spirit. In its formal character it opens the Cinquecento; it belongs to the stylistic chapter of the High Renaissance. But it was conceived in a particular period of time and belonged to a specific moment. That moment grew from conditions of the late Quattrocento.

To understand this period requires a steady effort to look beyond individual works of art in order to reconstruct the shape of an invisible but historically tangible ideal. This the documentation of the prehistory of the David encourages. And it is perhaps a salutory experience for our modern minds to be forced to look at the genesis of a work of art as part of a large segment of time as well as of its own particular moment of physical creation. The sequence of attempts to solve a problem of monumental scale and expression for the iconography of a whole city opens up a different vista from the one we are given by Vasari. This long-term historical development of the David has much in common with the slow growth characteristic of the democratic process, which Florence, in 1500, was still attempting to make function in its republican form. The parallel situation in a program such as

that of the Duomo Tribuna Prophets does not throw into relief individual creations but tends instead to merge their contours in a fluid continuity over several generations. Invention in this case belongs to no single moment. It grows, dwindles, revives again. Its life is governed by rhythms and stimuli that cannot be encompassed by any man's lifetime nor charted on any scale of individual genius.

How does an artist find his identity? Is it by an escape into the self to cultivate individual genius? Or is it by entering into the main stream of tradition, and by losing "identity," paradoxically, to find self? In Michelangelo's case there is something to be said for either alternative. Vasari and the sixteenth century and the Romantics of the nineteenth century would claim the validity of the first; the second would be upheld not only by Cennino Cennini but probably by Alberti, too. Michelangelo himself never gave his own answer clearly.

Nonetheless we know from his early work, beginning with the drawings of his juvenilia, that he was far from scorning his predecessors. By joining the program of the Duomo Prophets, old-fashioned as it might have been, he was joining the ranks of traditional greatness. One is inclined today, and in many ways rightly so, to place an emphasis on the influence of Jacopo della Quercia upon whose traces the young Michelangelo had come in Bologna in 1495–96. But over Michelangelo's David the shadow of Donatello projects itself overwhelmingly. It was Donatello who had provided the continuing energy for the program of colossi for the Duomo Tribuna up to 1455. It was not the unknown "Simone da Fiesole" of Vasari's report nor even the historically

40

real Agostino di Duccio with whom the young Michelangelo found himself in a kind of competition in finishing the marble David. It was the far greater citizens of Florentine art: Donatello and to some extent Brunelleschi. It was the ghostly glance of those titans that he must have felt over his shoulder as he began to work. And he must have felt a virtually unbearable tension between the achievements of the great corporate past and the ideals of his own precarious and more individualistic present.

3

Symbolism: Form, Image, and Placement

"Nec certam sedem, nec propriam faciem, nec munus ullum peculiare tibi dedimus, o Adam, ut quam sedem, quam faciem, quae munera tute optaveris, ea, pro voto, tua sententia, habeas et possideas. Definita ceteris natura intra praescriptas a nobis leges coercetur. Tu, nullis angustiis coercitus, pro tuo arbitrio, in cuius manu te posui, tibi illam praefinies. Medium te mundi posui, ut circumspiceres inde commodius quicquid est in mondo. Nec te caelestem neque terrenum, neque mortalem neque immortalem fecimus, ut tui ipsius quasi arbitrarius honorariusque plastes et fictor, in quam malueris tute formam effingas. Poteris in inferiora quae sunt bruta degenerare; poteris in superiora quae sunt divina ex tui animi sententia regenerari."

"Neither a fixed abode nor a form that is thine alone nor any function peculiar to thyself have we given thee, Adam, to the end that according to thy longing and according to thy judgment thou mayest have and possess what abode, what form, and what functions thou thyself shalt desire. The nature of all other beings is limited and constrained within the bounds of laws prescribed by Us. Thou, constrained by no limits, in accordance with thine own free will, in whose hand We have placed thee, shalt ordain for thyself the limits of thy nature. We have set thee at the center of the universe that thou mayest from thence more easily observe whatever is in the world. We have made thee neither of heaven nor of earth, neither mortal nor immortal, so that with freedom of choice and with honor, as though the sculptor and molder of thyself, thou mayest fashion thyself in whatever shape thou shalt prefer. Thou shalt have the power to degenerate into the lower forms of life, which are brutish. Thou shalt have the power, out of thy soul's judgment, to be reborn into the higher forms, which are divine."[1]

—Giovanni Pico della Mirandola, *Oration on the Dignity of Man*, 1486.

WHEN we now consider the David as the statue that was completed by Michelangelo we can see it in a new, or at least much modified, light. To the generic symbolic content of civic freedom which is to be found repeatedly in the Davids of Florentine sculpture and painting of the Quattrocento (see Fig. 14), this particular David introduced specific meanings and allusions of its own, peculiar to its period and perhaps also to the personal beliefs of its sculptor.

First, the commission, as we have seen, linked Michelangelo with the oldest continuing sculptural program in the Florence of his time. This meant he could establish his professional identity as part of the tradition vividly represented by the Duomo Prophets. Second, the marble he had inherited was not, as Vasari claimed, merely the badly botched beginning by a nobody, "Simone da Fiesole," or by an indifferent statuary sculptor, as history has labeled Agostino di Duccio. Instead it seems to have borne, in its design at least, the imprint of the mind of the greatest Florentine sculptor of the Quattrocento—Donatello. The young Michelangelo was given the challenge of completing what Donatello had imagined but had been unable to see finished. He was thus to measure himself in a competition with the highest of the

45

Florentine past. Here was another aspect of his contest with a giant. As he approached his task, Michelangelo had to identify himself as an equal of Donatello within the Florentine tradition, and may well have felt that as the representative of a new generation of artists he had to surpass him. And thus there came into being the familiar yet constantly inspiring figure: the oversize head turned to the left, brows creased over apprehensive eyes; the huge left hand concealing the end of the sling at the left shoulder, right arm with huge right hand concealing the stone hanging at the right thigh; short, narrow, muscle-sleek torso; strong legs with the weight on the right foot. The pose hovers between repose and action, between contemplation and physical energy: clean lines, clear forms, defined in whitest marble— courage, tension, hope (Fig. 15).

With the David successfully completed, Michelangelo brought more than a marble "back to life," as Vasari put it. At another level of meaning he was reasserting the function of figural art itself, in the older sense of making the absent present, or in Leone Battista Alberti's phrase, making "the dead seem almost alive."[2] Nowhere is this accomplishment more striking than in the way Michelangelo poured revivals and echoes of Greco-Roman Antiquity into the image (or what he might have called the *concetto*) of his David.

In Rome, where he lived between 1496 and the spring of 1501, the Antique was a steadily present visual and intellectual goad to inspiration. Each day brought to light new discoveries from underground. Collectors, including his own Roman patrons Cardinal Riario and the banker Jacopo Galli, vied tirelessly to increase their holdings, not all, it would seem, entirely free from

suspicions of enthusiastic forgery. In Florence before 1494, in the Medici household, the young sculptor would have been introduced to what was then the major collection of antiquities in Europe with the possible exception of the papal holdings in the Belvedere, or the Roman municipal collection in the Capitoline. His eyes had been fully opened; in fact, before he left Florence in 1495 he had made an Eros which had been taken for a genuine antique.[3] His firsthand knowledge of colossal statuary in Rome probably deeply affected his approach to the carving of his own colossus.

In 1486 in the debris of the interior of the semi-ruined Basilica of Maxentius were discovered the remains of a marble Late Imperial colossus: a huge hand and head. The latter is now all too familiar to every student of art history, but it was then exciting evidence of the greatness of the Roman past (Fig. 17). In 1492 the fragments of the colossus were placed in the Palazzo dei Conservatori on the Capitoline (where they are still preserved in the courtyard), and there the young Michelangelo could have studied them frequently between 1495 and 1500. The colossal head with its dense crown of matted hair, enormous eyes, rounded chin, and delicate yet sensuous mouth, has much in common with the head of the David. But the troubled expression and knotted brow, the vivid sense of tension in the neck muscles of the David of 1501–04 are quite different (Fig. 18). In this respect the David is preceded by Michelangelo's much smaller carving of St. Proculus of 1495 on the Shrine of St. Dominic in Bologna (Fig. 19). The St. Proculus, an "angry young man" if there ever was one, is not infrequently considered today to be a self-portrait. The David's head is a combination of the elements of the St. Proculus and the Roman 47

colossus—it falls at a mid-point between them, a synthesis of past and present, personal and impersonal, small-scale and large-scale. ⁾

√ The colossal mode of Antiquity probably also had a connection with the huge right hand which hangs at the thigh of Michelangelo's David (Fig. 20). Frequently the size of the hand is explained as an attempt to suggest the gangling, overgrown characteristics of adolescence in the young David. This explanation has never rung true to what is known of Michelangelo's ideas or likely intentions. He carved not from a live model but from an idealized image in his mind's eye. Studies from the life were only a first step toward a long-pondered conclusion.

√ The hand, with the thumb so prominent, is more likely a reference to the Capitoline Antique fragment or, even more probably, to Pliny's description of the Colossus of Rhodes, which figured in the conception of the Duomo colossus projected in 1415. In his *Historia Naturalis,* Pliny the Elder suggests the huge scale of the Rhodian colossus, which had already fallen in his day, by saying that "few men can embrace the thumb in the span of both arms."[4] The Renaissance, as one can see through an engraving after a design by Maerten van Heemskerck (Fig. 21) imagined not only fragments of a huge head and a hand, which two men are engaged in measuring, but conjured up as well a vision of the complete colossus as it stood, before the fateful earthquake, astride the entrance to the Rhodian harbor.

The colossus is shown in Figure 21 as a sun deity holding a torch, not unlike a later female colossal statue at the entrance to a harbor in the New World; he bears the attributes of the archer Apollo—the quiver and bow at his back. The bronze Roman

48

Colossus that once stood close by the Flavian Amphitheater was also a sun deity, despite the features of two Roman emperors given to it successively. Sun imagery was for Antiquity symbolic of the power of justice: *Sol Justitiae.* This imagery was early applied to Christ as Judge. The civilizing power of justice within the structure of the state was, of course, equally appropriate in Christian Florence to the freedom image of David. The reference to Apollo in the allusions to the great colossi of Antiquity adds still further to the poetic reach of imagination that we saw first in Michelangelo's self-identifying words on the Louvre sheet of drawings: "David with his sling and I with my bow."

To the meanings called up by these references to the colossal mode in Antiquity the young Michelangelo added others. No one set of symbols can properly be called dominant in the intricately layered structure of meaning that the statue as a whole embodies; by the same token, probably no dominant type of figural art, no specific subject from the past can be singled out as the determinant of the form the statue assumed.

For the convention of the full nude that Michelangelo chose for his David, the general precedent of the heroic nude in Antique art and Early Italian art inspired by the Antique may be invoked. The lineage is clear in its main elements. Nicola Pisano had used the full nude, at small scale to be sure, for his Fortitude-Hercules figure on the pulpit of 1260 in the Baptistery at Pisa. And Hercules, draped only over the left arm, appears, also at small scale, a little over a century later on the Porta della Mandorla of the Cathedral of Florence (Fig. 12). The model in Antiquity for this Florentine Hercules is probably impossible to locate today,[5] but the figure's

49

system of proportions, with the head length approximately one-seventh of the length of the whole figure, is much closer to the Antique norm than to the large-headed Nicola Pisano Hercules. In fact, it rather closely approximates the canon that had been proposed by Vitruvius in the first century A.D., revived in Leonardo's striking drawing of the man of perfect proportions inscribed in the square and circle (Fig. 13).

Related to, but not dependent on, the Vitruvian canon was Alberti's modular system in which the human figure was divided into six parts, or "feet," in turn subdivided twice by ten "degrees" and ten "minutes."[6] The surveyor's and geographer's terminology is not inconsequential. Just as the globe of the earth is measured by degrees, minutes, and seconds, so man is measured by an analogous method; macrocosm and microcosm of the old medieval idea inherited from Antiquity are thus related systematically. There is internal evidence that Donatello's David of the Casa Martelli and his bronze David were inspired by Alberti's canon; at least, the measured intervals of the figures' construction work out very closely to each other and to the ideal proposed arithmetically by Alberti (see Fig. 14). Donatello would have known Alberti in Rome between 1431 and 1433, and it may be proposed with some confidence that their friendship led to these exercises in modular design.[7]

If only because the David of 1501–04 was first designed for placement on the Tribuna of the Duomo, immediately adjacent to the Porta della Mandorla, the little Hercules of that portal must have caught and held Michelangelo's attention. And, in fact, the stance with the weight on the right foot and the relaxed, curving shift of axis in the torso so noticeable in the huge David

may be found in a preliminary version in the small Duomo Hercules (see again Fig. 12 in comparison with Fig. 15). The Duomo Hercules differs from the marble David in its proportion of head (or face) to total height. Michelangelo abandoned a canon for his colossus; the large head may be a memory of the Roman colossal head of the Capitoline, but its size may also have an explanation in the high emplacement on the Tribuna buttress originally planned for the statue. At such a height enlargement of the head and features for the sake of visibility at ground level would be understandable and, in terms of Quattrocento practice, altogether justified. Donatello had enlarged the heads, hands, and feet of the statuary he designed in 1415 for niches high above street level on the Duomo Campanile.[8] It should be remembered too that on the Tribuna, Michelangelo's free-standing statue would have had immediate visual relation with vastness of sky and more-than-worldly space. The mythological overtones of meaning inherent in the Hercules theme lead to the cosmic.

Michelangelo's huge David has about it the aura of the absolute. Its cleanness of line and purity of finished forms suggest an origin deep back in time when the earth was still fresh and mankind still uncorrupted. Thus the David is also an Adam. Is there possibly a connection here with the figure derived from Quercia's Adam on the *verso* of the Louvre drawing? In any case, the finished David recalls nothing so clearly as the hero of the myth of Creation with which Giovanni Pico della Mirandola toward the end of the Quattrocento introduced his *Oration on the Dignity of Man*. The oration, written in 1486, was to introduce no less than nine hundred doctrinal theses which Pico hoped would reconcile Christian dogma with the teachings of all religions and

51

philosophies. According to Pico, man, symbolized by Adam, was created without a specific niche in nature; he was given an indeterminiate yet universal nature of his own, and with this gift came his freedom, the essential element of human dignity. In Pico's reworking of Genesis, God is made to address Adam in a sinless Eden with no serpent in evidence and no Temptation and Fall in sight:

The nature of all other beings is limited and constrained within the bounds of laws prescribed by Us. Thou, constrained by no limits, in accordance with thine own free will, in whose hand We have placed thee, shalt ordain for thyself the limits of thy nature.

Pico's God, in a way which is somewhat reminiscent of Sartre's absence of God in modern Existentialism, leaves Adam alone,[9] and the extended metaphor of creation boldly shifts to the metaphor of Man as a self-sculptor:

We have set thee at the center of the universe that thou mayest from thence more easily observe whatever is in the world. We have made thee neither of heaven nor of earth, neither mortal nor immortal, so that with freedom of choice and with honor, as though the sculptor and moulder of thyself thou mayest fashion thyself in whatever form thou shalt prefer. Thou shalt have the power to degenerate into the lower forms of life, which are brutish. Thou shalt have the power out of thy soul's judgment to be reborn into the higher forms which are divine...

Often this famous statement is rendered in such a way that what is translated here as "sculptor and moulder" appears as "maker and moulder." But Pico's Latin is unmistakable; he uses the words *plastes* and *fictor*, which apply to the process of modeling

sculptural forms for casting. The metaphor is thus of the statuary's art precisely in the restrictive sense of *statua* used by Pliny the Elder.[10]

Pico, with Ficino and Poliziano, was a member of the Careggi set that met in the Medici villa at Careggi, mentioned earlier in connection with Michelangelo's formative years in Florence. To what extent Michelangelo might have absorbed Pico's doctrine of mankind as sculptor of the self is difficult to know. But the idea of the self as both sculptor and subject for sculpture is so close to the metaphor used by Plotinus in relation to the soul's recognition of the good (see p. 15) that we can be reasonably sure it was discussed in the Medici circle of around 1490. To that extent at least the search for identity may have been given a fundamental direction not only toward the image of the practitioner of sculpture but toward the image of man in marble, *homo magnus et albus*. In fact, as well as in theory, the two merge. Identity in this situation becomes reciprocal. The sculptor meets himself in the figure of marble. He becomes his own "Gigante."

The vibrant St. Proculus on the cover of the shrine of St. Dominic of San Domenico, Bologna, had emerged only a few years before, in 1495, as an idealized self-portrait. Although the young saint is clothed (Fig. 16), the pose is a prefiguration of the nude David in three important respects: stance and balance of weight on strong legs, small lithe torso twisting slightly, left arm bent at the elbow with right arm in contrast extended.[11] We have noticed earlier the likeness of features in both heads and the fiercely glowering eyes under the heavily knitted brow. Resentfulness, scorn, concentration on the self and its problems are mingled here. It would seem to be an active mood of indepen-

dence, precursor of the saturnine mood of brooding melancholy that the Italian Renaissance associated with artistic genius.[12]

We find the same knitted brow in the Nicodemus of the Lamentation group by Niccolò dell'Arca, Michelangelo's strongly temperamental predecessor in Bologna.[13] We find it, too, in Leonardo's da Vinci's ideal canon after Vitruvius that we earlier looked at in connection with studies of proportion. The head is remarkably carefully finished, worked out in stronger contrast of light and dark than the remainder of the figure (Fig. 22); minus the beard of the famous Turin self-portrait, it is essentially the same face (Fig. 23). The eyes have the same cold intensity; the searching glance is the image of Leonardo's well-known motto *saper vedere:* "Know how to see," or perhaps "See in order to know."

Thus self and ideal meet not only in Leonardo's nude but in Michelangelo's marble figure. What in the colossus might have turned into an exercise of mere exhibitionism on the theme of physical power is saved by the suggestion of psychic force and emphasis on individuality. What might have descended into egotism is redeemed by reference to a type, indeed to an archetype. Here is an expression of physical and moral strength but not of overweening hubris. The sculptor subdued the attributes of the usual David theme so that the statue recalled clearly not only Adam but the traditional classicizing Hercules of earlier Florentine sculpture; and in doing this he also recalled Hercules as one of the traditional patrons of the Florentine Republic, a subject with which he had experimented (in a now lost statue) before 1495.[14] The Hercules theme in turn recalled the colossus of terracotta executed by Agostino di Duccio under what we assume to have

been Donatello's direction. Similarly, it suggested the project for the Hercules of 1415 by Donatello and Brunelleschi for the Duomo Prophet-series, the traditional libertarian imagery of the city's religious center.

And at still another level of meaning, as a companion to Hercules, the David is the personification of the revived Florentine Republic of 1500, of the heroic yet indecisive interim between the fall of Savonarola and the reinstated Medici. It is the apotheosis of the *res publica,* or *"cosa pubblica,"* as it was to be called in 1504 by Giuliano da San Gallo. It was an image of personal and corporate freedom, and essentially one of righteousness; it redefined the ethical content of Masaccio's Tribute Money but in a new mode. Michelangelo's colossus of Florence was intended as inspiration for a new and heroic generation of citizens. The huge man of marble was designed by its artist to be a force in the creation of a new age.

Seen in this light, the process of creation appears truly to be a process of identification. In more than theory it could link the real to the ideal, the individual to the commonwealth. The creation of the David involved the artist profoundly, and he in turn reached out directly and searchingly to the citizens of early sixteenth-century Florence. Just so do we find in the David, as if in a historical mirror, the reflection of our own identity. In this respect, even beyond its physical beauty and power, the David can still touch us deeply across the centuries.

There has been a growing reaction among historians of Renaissance art against a facile equating of events in political and social history with events in art history. In some cases this 55

criticism is justified; but Michelangelo's David demands a knowl-
edge of contemporary political events before one can understand
it as a work of art. We know today, through relatively recent
studies, that the crisis in Florentine political history in 1501 vividly
recalled to the Florentines themselves the history of the Milanese
threat of 1400.[15] The idea of reactivating the program of the
Tribuna sculpture in 1500–01 seems to have been a deliberate
recall of the famous public and civic competition for the Bap-
tistery Doors — exactly one hundred years before, and strikingly
enough on a parallel Old Testament theme of freedom and a
people's salvation. In the moment of danger that opened the six-
teenth century in Florence, with Cesare Borgia's army threatening
not only the satellite cities of Tuscany but Florence itself, with
French aid hanging in the balance, with the city treasury far from
full, and leadership weak or in doubt, there was reason to appeal
to the support of historical memory: the memory, especially, of
consecrated idealism and civic dignity preserved in the medieval
Duomo, still vibrant with echoes of the age of Dante and of Giotto,
where figures of marble prophets set high up were intended to
lead the mind upward from the city-state of man to the city-state
of God.

As of 1500, despite the impression spread by Vasari, the
medieval and Early Renaissance republican past was not an
archaism ready to give way to a wave of the future. As far as one
can judge, that very republican past appeared to the majority of
influential Florentines not as an adversary but as the only ally
they could fully trust. But by 1504 the historical accent had shifted
from the Duomo to the secular symbol of power in the city's urban
iconography: the piazza of the Signoria and the triple complex of

palace, related loggia and public square. This shift of symbolic accent with the shift of location requires interpretation.

We know nothing of the mechanism which triggered the decision to abandon the original intention of placing the David on a Tribuna buttress of the Duomo. We do know, though, that as late as the early months of 1504, when the statue must have been completed or nearly so, no final decision on where to place the statue had yet been taken. But by then it must have been evident to those who had followed Michelangelo's progress in the statue, that the originally intended placement high on the buttress of the Duomo should be abandoned. There remained still to be thrashed out the question of whether the statue would stand in front of the Duomo, and so be in visual and symbolic contact with the traditional religious center, or be placed somewhere in the square of the Palazzo della Signoria, at the political heart of the city. There is evidence in the record of a *practica,* or inquiry, held in January of 1504, that Michelangelo had his own ideas, and that although he was not present to plead for them he was far from unrepresented by some of his fellow artists who were consulted.

The shift from the Duomo to the Piazza della Signoria did not involve a long physical journey. It was a displacement of only a few city blocks (see Fig. 24). The move may have been motivated by visual reasons (the detail of the statue was likely to be lost visually at a great height) or by engineering reasons involved with lifting so huge and delicate a piece of marble to the height of the buttress and maintaining it there. But the ultimate decision to move the David to the square of the city government is explainable for more significant reasons of symbolic suitability.

By the end of the Quattrocento the grip of the Church had

57

begun to weaken as a result of humanist pressures. The world was increasingly seen through the image of Antiquity. The ideal Renaissance city, as shown in a fifteenth-century panel, contains as a focus of perspective the representation of a typical government palace, but to find it one must look through the representation of an Antique triumphal arch.[16] The visual conjunction carries historical overtones. In Florence toward 1500, the balance of church and state had already begun to shift. Only six years before, the Piazza della Signoria had been the scene of the death of Savonarola's God-directed control of government with the friar's own execution and burning there (Fig. 25).

When he wrote of the marble David in 1550, some fifty years after the event and twenty years after the Florentine Republic had been finally extinguished, Vasari saw the statue far differently. To him it was an emblem of the Prince's power ("insegno del Palazzo"). He saw not David the shepherd boy but David the King, whom he related to the princely ideal of justice of his patron, Duke Cosimo I. There is no relevance here to the earlier Quattrocento ideal of republican virtue.

The strongly authoritarian bias in Vasari's account should not come as a surprise; but it is so overlaid with his enthusiasm for the older Florentine tradition in art that it can easily escape notice. Certainly it is very much part of the atmosphere of Florence in the mid-sixteenth century, the Florence that Michelangelo himself was careful to avoid by going off to Rome.

Vasari's anti-libertarian bias is revealed in his gratuitous casting of the weak Gonfalonier-for-life, Pietro Soderini, in the role of enlightened individual patron, as we have already noted.

It is seen again in his story of the way the statue finally was placed, not on the Duomo Tribuna as originally intended, but on the *ringhiera* (or ceremonial parapet) at the base of the façade of the Palazzo Vecchio. Vasari's inference is that in putting the statue at the entrance level it was subordinated to the Prince and his justice and power; for the entrance-portal of the ducal residence was the actual as well as metaphorical door for his subjects who were supplicants for justice. Vasari's further inference is that this position for the statue was desired by Michelangelo in 1504.

Probably by 1508, when Michelangelo was consulted by the Florentines about the possibility of making a composition on the Hercules theme to balance the marble David in front of the palace near the entrance, he had become reconciled to the decision of the Signoria in 1504 to place the David in a spot subordinate to the lower mass of the palace architecture. But this evidently was not his view in the early months of 1504, when the placement of the colossal David was under public debate. A close reading of the record clearly shows that Michelangelo wished to see his figure placed under the central arch of the Loggia of the Signoria, situated at right angles to the entrance wall of the palace. Such a position would give the statue architectural support but at the same time would provide it with a certain amount of isolation. No more honorable position in the whole city could be envisaged than this Loggia with its own strong triple-opening, the traditional scene of outdoor civic ceremony.

Michelangelo, fresh from Rome in 1501, may have had in the back of his mind the triple arch of the Basilica of Maxentius in the Roman forum (Fig. 26). At the end of the Quattrocento that

59

building was much as we see it today, but it carried the name "Temple of Peace" — a title which would have had reverberation in war-threatened Florence of 1501–04.

A tradition of Michelangelo's preference for the Loggia has continued as a kind of counterweight to Vasari's view. Although it is a late source, Borghini's *Riposo* contains a passage which reflects clearly that tradition. In 1921 Erwin Panofsky urged serious consideration of Borghini's passage, and I would like to reiterate that urging here.[17] As the artist involved, Michelangelo quite properly could not take part in the debate of 1504, and his testimony is not part of the record.[18] But there can be no reasonable doubt that his ideas were presented by others, the major spokesman being Giuliano da San Gallo; and on analysis of the record there should be no question as to what those views were.

In 1504 the Loggia was empty. It was close to the palace of the Signoria but was not to be confused visually with the palace. Under the Medici Dukes statuary was indeed put in the Loggia in prominent positions under the arches, where in two cases it is still very much on public view. Thus Michelangelo's concept of the Loggia as the location of statuary was later adopted, but ironically this was to come about without his own statue as a central dominating element, as he evidently hoped.

As usual, he was instinctively in the right.

An experimental photomontage made to approximate scale shows how the David would look today if it had been placed where the artist seems to have wanted it (Fig. 27). There, the full meaning of the republican imagery would have been evident; the statue would have found a far more fitting place from which to project its eloquent message with trumpet-like authority. There,

60

symbolically, the artist as a Florentine citizen might have liked to visualize himself.

The record of the discussion of 1504 on the placement of the statue (which indeed looks very much like a stenographic report) offers a rare opportunity to watch the Florentine democratic process in action. Citizen-artists of all kinds and ages, some beautifully educated such as Leonardo da Vinci, some hardly able to string two coherent ideas together, were given the opportunity of expressing their views (see Appendix II-B, pp. 141–57). Only two artists, Botticelli and Cosimo Rosselli, spoke in favor of erecting the David in the area of the Duomo. It is worth noting that both were of an older generation, and that Botticelli had been openly an ardent *piagnone,* or ultra-religious supporter of Savonarola.

In favor of a placement on the palazzo *ringhiera,* or in the court inside the palazzo, were a number of artists who echoed or supported the long opening statement made by a representative of the government, the herald Francesco Filareti. He held that the statue would look well in the open and that it would replace Donatello's Judith and Holofernes, which was later moved to the Loggia della Signoria. (The Judith, one must admit, is indeed too slight in scale for a place on the *ringhiera.*) But in addition, Donatello's group was not, in the words of the official, a fitting subject since the image of a woman killing a man was scarcely a proper emblem for the city. And besides, he reasoned, ever since it had been set up under an evil star it had brought Florence bad luck in external affairs.

The appeal to superstition included in this *plaidoyer* of the representative of the Signoria may seem to strike an unexpected

61

note. But the belief in the influence of the stars was if anything stronger under Neoplatonism at the end of the Quattrocento than at the beginning of the century, and Florence was caught in a particularly grim crisis. The herald probably knew his business and must have counted on a favorable psychological reaction. The tone of the long speech, however, is not in the least inflammatory and deserved the attention it undoubtedly received (see Appendix II-B, pp. 143–45).

The third suggested emplacement, as we have seen earlier, was under the vaults of the Loggia, designed for outdoor civic ceremony and built simply and grandly on a monumental scale. One argument in favor of this emplacement was that the marble would be better protected under cover, a factor later borne out as realistic, and that it might be better seen, since the white marble would contrast against the wall.

The artists supporting this view were as numerous, or nearly so, as those who appeared to favor the official governmental position. The most articulate among them was Giuliano da San Gallo, Michelangelo's friend who a few months later was to rig the complicated rope fastenings and wooden scaffolding necessary to keep the statue erect and stable during the precarious journey from the Cathedral shops to the Piazza della Signoria. San Gallo's views are interesting, not least because of the firm yet tactful way they are expressed. He said that for a time he had espoused Cosimo Rosselli's suggestion for a placement on the piazza close by the Duomo, where the statue "would be seen by the people." But, he continued, "consider that this [statue] is a public matter [*cosa pubblica*] and consider the character of the marble which is delicate...if it is placed outside and exposed to the weather...it

will not endure." San Gallo concluded as follows:

I thought that it would be better underneath the central arch of the Loggia of the Signoria: either underneath the center of the vault, so that you can go in and walk around it; or else right at the back by the wall in the middle, with a dark niche behind it as a sort of tabernacle.[19]

Leonardo's testimony was brief and somewhat cool. One gathers that although he may have been no great supporter of Michelangelo, he was not his enemy on this matter. Indeed, he appears to have wholeheartedly backed Michelangelo's views, even to the point of meeting the argument of the second spokesman for the government who felt that if the statue were placed beneath the central arch of the Loggia it would interfere with "the ceremonies that the Signoria, and other magistrates conduct there."[20]

Finally, one must single out the speech of Piero di Cosimo, close friend of Giuliano and Antonio da San Gallo. He urged the Loggia as the best place for setting up the David mainly because it was the choice of the artist. Piero spoke simply and directly:

I agree with Giuliano da San Gallo. Even more I would approve an opinion in agreement with him who made it [the statue] since he knows best where he wants it to be.[21]

Although it might be argued that Piero's statement about Michelangelo's own preference is introduced in opposition to San Gallo's, the whole context does not support this interpretation. What Piero actually seems to be saying is that he backs the proposal made by San Gallo, especially since it coincides with the artist's own opinion, which he respects even more.

A Renaissance statue is not completed until it takes its place in 63

human environment. Let us suppose the project of placing the David under the central arch of the grandiose Trecento Loggia had been completed. What would have been its effect on future events or ideas about art in Italy? How would it have affected our own ideas about the Renaissance or our views on Michelangelo's personal style and its source and effects? Of course, we cannot know but several assumptions seem clear.

In the first place, the shelter of the central arch of the Loggia would have offered a safer and probably a far more appropriate home for the David. It would have been protected against weather and physical accident, both sources of actual damage over the centuries when the statue stood near the entrance door of the palace. It is very likely that the statue would still be in its original, intended place instead of being incarcerated some blocks away in the Accademia, and the ambiguity of a poor modern copy would not have been forced upon us at the piazza site. We would see with more immediacy the intended role of the statue in the city's space and urban iconography—not a small matter. Probably also the character of the colossal scale would have been more easily grasped by our eyes and minds. The brilliant whiteness of the marble, its effect of being in its own right a source of light, would be more apparent.

The asymmetric placing of the statue to the right of the main portal of the palace in 1504 created at once a problem of esthetics. As early as 1508, and again in 1525, a balancing composition was called for. The statuary group on the Hercules theme that Michelangelo was to have carved as a pendant to his David ultimately became, as is well known, the controversial Hercules and Cacus of Baccio Bandinelli which is still in place. The same motif of

paired colossi occurred in Venice. Huge statues of Mars and Neptune, suitable subjects for the Venetian state, were carved by Jacopo Sansovino to flank the inner entrance of the Doges' Palace at the summit of Rizzo's beautiful staircase—now known as the "Scala dei Giganti." In Florence there soon followed Ammanati's colossal marble Neptune for the fountain near the northwest corner of the Palazzo Vecchio—*l'uomo bianco*, as he was called by the Florentines. Thus the Quattrocento term *homo magnus et albus* continued by a circuitous route clear to the academic stage of Mannerist sculpture.

But, emphatically, the David of Michelangelo is not a Mannerist work of art. Its own style as a statue requires a single dominant frontal view instead of the multiple views required by Mannerist art theory. It embodies a remarkable wholeness of effect and a striving for completeness in detail that belonged only for a brief moment to Michelangelo's personal development as a sculptor. Even more than the sculpture of Andrea Sansovino, the David ushers in the High Renaissance. It required for its maximum effect the kind of emplacement the central arch of the Loggia would have provided.

If, in 1504, that emplacement had been chosen, the statue would have provided a focus for the potentially important cross-axis of the Piazza della Signoria. As the terminal goal of a rational, ordered space, from north to south, it would have contributed a new dimension to the Piazza's repertory of spatial experience. We have been so conditioned since the Quattrocento to think of the Piazza with the Palace as a central focus (see again Fig. 25) that the potential interest of the cross-axis with the Loggia as a focus may be forgotten. If that interest had been stressed, we would long

ago have perceived what Raphael understood clearly at the time he composed his painting, "The School of Athens" (Fig. 28). A central arch, within enclosing arches, frames a central figural motif. There also Raphael was to pay his own homage to the sculptor of the David and the painter of the Sistine ceiling by giving Michelangelo's features to the powerful, melancholic philosopher seated in the foreground (Fig. 29).

4

Epilogue: Self and Time

Un gigante v'è ancor d'altezza tanta
che da sua ochi noi qua giù non vede;
e molte volte a rricoperta e franta
una cicta collà pianta del piede.

Still there lives a giant of such height
That he does not make us out down here below;
Many a time he's kicked and crushed
An entire city with his foot's weight.[1]

—Michelangelo, *c.* 1535, in Rome

TO the moment of high synthesis, of hope mingled with nostalgia for even grander things, came an epilogue which is briefly told, but not so quickly forgotten. The idealistic dreams of the first decade of the sixteenth century were soon out of date. In 1530 the Florentine Republic was snuffed out permanently, and the dark-visaged, ill-omened Alessandro de' Medici was installed as hereditary Duke, to be followed after his assassination by Cosimo I.

Under these circumstances Michelangelo left Florence only too gladly, never to return. Thereafter in Rome, virtually as an exile, he followed events in his native city scornfully, bitterly, and with unfailing interest. With the change of fortunes of his city, his view of himself changed also. The heroic interlude of identity with the colossal David was short-lived.

By 1510, Raphael's portrait of Michelangelo as the seated, brooding philosophical figure dominating the foreground of the School of Athens had already established a far darker image of the artist (Fig. 29). The earlier, aggressive, proto-melancholic characteristics, such as could be found in the sculpture of Niccolò dell'Arca, or in Michelangelo's St. Proculus in Bologna and the knitted brows of his David in Florence, grew under Raphael's

brush into a large-scaled, hulking, inward-looking contemplator. This is the typical child of Saturn, the melancholic par excellence as defined most vividly for the Italian Renaissance mind by Petrarch and elaborated by Ficino.[2]

The bulky, immobile figure is the only one dressed in contemporary costume in the entire composition of the School of Athens. It is clearly a peasant's costume. Michelangelo is shown with legs crossed, seated heavily on one block of cut building stone and leaning wearily on another, the while pondering his next words in writing. Saturn's nature, as transmitted by Petrarch to the Italian Renaissance, was related to the element of earth and hence was described as "uncouth" and "rustic" (*agrestis, rusticus*). This accounts for the peasant's costume. But even more striking is the identification of Raphael's visual concept with Petrarch's description of Melancholy in one of the *Canzoni*. There Melancholy (in Petrarch's traditional Italian imagery a man, and not a woman, as in the tradition picked up by Dürer) describes himself in the following verses:

> "I am cold; dead stone in living stone
> [I have] the appearance of a man who thinks and weeps and
> writes."
> *Me freddo, pietra morta in pietra viva,*
> *La guisa d'uom che pensi e piange e scriva.*
> — *Canzoni*, 129[3]

Not only are the features of Raphael's brooding philosopher Michelangelo's, but the forms and colors are wittily selected from those of his clothed figures of the Sistine Ceiling. It is not pushing the visual evidence too far to say that it is verse (from the length

of the lines) and not prose that is on the sheet of paper held by the philosopher. One would like to be able to know what those verses are, but what looks like writing at a distance is, when examined close to, only imitative scribble. We should not feel too cheated; probably Raphael could not be expected to have known what Michelangelo would write.

Next, melodramatically melancholic, if not downright maso-chistic, is the famous self-portrait in the form of a grisly carica-ture on the skin of St. Bartholomew in Michelangelo's Last Judgment on the altar-wall of the Sistine (Fig. 30). The human skin is draped from the disdainful hand of the saint, who is supposed traditionally to represent the artist's relentless enemy and critic, Pietro Aretino. The flayed, eyeless mask is swarthy, and the hair of the sixty-year-old artist is still black, as befits the classic physical type of the Renaissance melancholic. But there is a funda-mental change. Now, toward 1540, the suggestion of a separation between dispensable outer appearance and indomitable inner being sets up a new and desperately uncomfortable tension.

There are echoes of this mood of extreme disillusion in Michel-angelo's writings. In one letter, he ridicules with heavy irony the idea of a Medici colossus apparently proposed by Cardinal Giulio de' Medici. The new colossus, Michelangelo wrote, might be made to sit and thus enclose a barbershop for income-pro-ducing property; or, standing, it might become the bell tower for the Medici church of San Lorenzo.[4] Nothing could be more powerful as a statement of pure disenchantment than a frag-mentary poem written in Rome, after his departure from Florence, on the theme of the giant.[5] We are given not a hero but a monster. He is a cyclops; but his one eye is set not in his forehead but in

one heel—mythologically and Biblically a vulnerable and despicable spot:

> Many a time he's kicked and crushed
> An entire city with his foot's weight.

As the verses run on it becomes only too clear that this is a bitter attack, none too carefully veiled, against the tyranny of the Medici over Florence. What is most valuable to us is to see the metamorphosis of the image of the giant from hero to villain, from a symbol of the justice of the sun's pure light to an image of the purblind giant who, towering into the skies and facing the sun, can see nothing:

> He aspires to the sun, and towers crumble underfoot
> As he tries to reach the sky, which he cannot see.

There follows the monstrous evocation of his aged wife—"huge, piggish, slow," who "nurtures the giant with her shriveled breasts" and

> ...hidden behind high walls
> Even when he's idle, she, in the living shades
> Casts deathly shadows on a deprived people.

This surely is an image of Florence herself under the sixteenth-century Medici tyranny. From the conjunction of blind giant and greedy crone nothing but evil can come. Thus their children, monstrous also, wander over the globe plotting and warring against justice. They are seven in number—"Riches," "Doubt," "Perhaps," "Falsehood," "How?," "Why?" and "Adulation"—the evils of the court and deadly enemies of citizenship within a free republic.[6]

This mood of terrifying disillusion in Michelangelo's own experience corresponds to general fears of world disorder and destruction. The reverse of a panel by Albrecht Dürer shows Lot and his daughters with Sodom and Gomorrah burning in the background (Fig. 31). The form of the cities' destruction, with its ominous mushroom-shaped clouds, prophetically strikes a note familiar to a much later generation. The theme of world destruction was taken up late in his life by Leonardo in a series of twelve unique and splendid apocalyptic drawings now at Windsor.[7] Leonardo saw in his mind's eye the toppling of mountains (Fig. 32), not unlike Lear's later vision of the cataracts and hurricanes drenching church steeples. He saw the elements unleashed in explosive force working in a colossal fury, annihilating all forms of life including mankind. The world is old, these drawings say. A cycle is about to close. The imagery is Stoic and also Epicurean. Listen, with this image in mind, to Lucretius' description of what he calls a "concentrated wind" that "blowing through subterranean caverns has come to a head and hurls itself against lofty vaults"[8] or to how "the whole substance and structure of the universe must one day crash."[9] In this Epicurean view, the world can live only through self-destruction and re-formation of its constituent atoms. In the related Stoic view, the order of the cosmos must periodically shatter so that it may be renewed.

The separation of humanity from the rest of creation which Michelangelo held as axiomatic, Leonardo denied: "This earth ... seeks to lose its life, desiring only continual reproduction and as ... like effects always follow like causes, animals are the images of the universe."[10]

As we watch Leonardo's hand moving with a freedom unparalleled for his time across the sheets of paper now at Windsor, the full fury of blind cosmic forces emerges more and more powerfully. Rock formations tumble. Wind and water swirl through space and into the void. They engulf the universe in all its measureless breadth and depth. The ways in which these cosmic-force symbols are stylized brings us to a point of enormous contemporary interest. Gone now are the personifications from the comforting Antique imagery of Olympian gods and all their train of sub-divinities. These swirling sky and water forces are actually most like the stylized sky-dragon shapes in the traditional painting of China.

The psychological differences between Leonardo and Michelangelo could hardly be more sharply drawn. Michelangelo's parallel imagery is Platonic, human, and soul-centered. In one of his most often quoted poems he wrote that "the best of artists" has access only to the *concetto,* or the soul-image, within the marble block. Potential man is represented by potential statue. For Michelangelo, humanity might be by primal definition the stuff of heroism, but it could never overcome the tragic flaw of the link of spirit to matter without ceasing to be human.

Tragedy is implicit in the titanic struggle of the Captives, carved for the tomb of Julius II, to free themselves from their marble matrix (Fig. 33). The visual metaphor of soul struggling to free itself from the physical body is immediately recognizable. More striking still is the suggestion that the human soul, theoretically perfectible, will never reach its goal of perfection. Thus, to carry the metaphor further, this sculpture can never be "finished."

74

This is the *non finito* in its most artistically and most devastatingly logical form. The more active the struggle, the deeper the ultimate disillusion. The greater the progress toward freedom, the more abysmal the falling back into inescapable bondage. The energy of these Captives cannot be released beyond the limits of the marble block. This is not a phenomenon of *ex*plosion as Dürer or Leonardo would have drawn it. It is on the contrary a phenomenon of *im*plosion, a release of power inwards into the block which the *concetto,* or soul-image, would like to shatter but cannot. The triumph of completion in the earlier David now turns into the tragedy of the unfinished work: the *non finito.* Man in a spiritual sense is destined to remain unfinished, perhaps even worse, still-born, as Petrarch had written, and Michelangelo himself repeated: "dead stone in living stone."

The wearing down of mind and will which this tragic struggle toward existence implies is evident in the weariness that seems to come out like a great sigh from Michelangelo's late Pietà of the mid-1540's. Here we find still another self-portrait (Fig. 34). In accord with custom the sculptor gave himself the role of Nicodemus, supporting the body of Christ.[11] In medieval lore, Nicodemus was a sculptor who had carved the image of the face of Christ (the *Volto Santo* as it is known still in Lucca), and the Bible tells us that after the Crucifixion it was he who "at the first came to Jesus by night and brought a mixture of myrrh and aloes about a hundred pound weight."[12]

Michelangelo's version of the stock iconographical aspect of this character is his own. The features of the main supporting figure are those of the sculptor himself, broken nose and all, but

75

generalized and eroded. Although the eyes are open, their gaze is blunted; they are unseeing eyes. Or more accurately they are eyes that no longer can see in any direction but inwards. Again one thinks of *King Lear;* and this time of the penitent, blinded Gloucester:

> I have no way, and therefore want no eyes.
> I stumbled when I saw.[13]

To such a denial is now reduced the proud Renaissance motto of Leonardo's *saper vedere.*

The Florence Pietà was intended by Michelangelo as a monument for his own tomb. More private still is the last Pietà (Figs. 35 and 36).[14] It is not an easy piece to grasp visually for it belongs to two separate periods of carving. The first stage was the near completion of a heroic group—a Christ supported by a standing Virgin. Then in the last years of his life Michelangelo began a revision that was actually a new conception. He worked toward an extraordinarily bold and beautiful curving design that leaps forward three and a half centuries in time to anticipate Rodin and Brancusi. All that is left of the first design is the arm of the original Christ standing like a stalagmite from an earlier geologic age. Now the Christ and the Virgin emerge as new evocations of the spirit. The Christ is cut back cruelly. In the shrinkage of the torso there is a suggestion of the physical process of wastage in extreme old age. Michelangelo was then in his ninetieth year, and it is as if, facing his own death, the artist were creating not the body of the traditional Savior but a body fading to the likeness of his own imagined corpse.

In technique the revised forms are muted, the strokes of the chisel unsure, the transitions clumsy. We know that one year before he died Michelangelo seems to have lost through paralysis most of the use of one hand. Yet even so, he worked on this sculpture for one whole day less than a week before he died. The carving looks as if it were done at fingertip, the sculptor groping for the form as if he were blind. If this were so, it would make this last work in stone the more complete in a spiritual sense, and the meaning of its pathos even deeper. The work is carried with infinite courage to the last limit of human endurance. Here the *non finito* is no longer a matter of esthetic choice.

We have come a long way from the David of 1501–04. With the furthest reaches of the late Michelangelo one begins to move into a region foreign to the Renaissance. One begins to touch the distant boundaries of poetic imagination suggested in *King Lear*. In the last years of Michelangelo, the content of that play is never far away—nor, indeed, are thoughts of Blaise Pascal. This is to leave the Renaissance and to enter a new period which will speak, not of the heroic human situation, but more simply, more directly, and perhaps more poignantly of the human condition. On February 18, 1564, Michelangelo died, about two months before Shakespeare was born.

Rich and varied as the new age would be, it could not diminish the startling clarity of the vision of the Italian Renaissance at its height, when the human self, at heroic scale, and with an urgent sense of freedom, was given the chance to be the lonely sculptor of its own being. The Renaissance message was addressed not to

77

the collective human species but to individual human selves. It was at the grandest possible scale. It was completely unsentimental. It meant precisely what it said (in Pico's words):

Thou shalt have the power to degenerate into the lower forms of life, which are brutish. Thou shalt have the power, out of thy soul's judgment, to be reborn into the higher forms which are divine.

⊲ This comes close to the heart of the David's meaning. It proclaims the ultimate freedom: the freedom to become what the self wants to be.

NOTES

General Bibliographical Note

THE 400th anniversary of Michelangelo's death in 1564 has produced a new influx of literature on the artist. The most valuable census of that recent literature is by Dr. Peter Meller and is included in the large commemorative volume of the half-millennium, *The Complete Works of Michelangelo*, ed. M. Salmi, New York, n.d.; this listing is in supplement to the classic basic bibliography of Steinmann and Wittkower (Leipzig, 1927). Dr. Meller lists previous supplements up to his own since the appearance of the Steinmann-Wittkower bibliography. The art-historical basis is given by Charles de Tolnay in *The Youth of Michelangelo*, Princeton, 1943, with revisions of his opinions and new ideas in the latest edition of his *Art and Thought of Michelangelo*, New York, 1964; see also the relevant section of J. Pope-Hennessy, *Introduction to Italian Sculpture of the High Renaissance and Baroque* (3 vols.), London–New York, 1964. For the drawings, in addition to de Tolnay, consult the late Bernard Berenson's *Drawings of the Florentine Painters*, particularly the revised editions of 1938 (University of Chicago Press) and 1961 (in Italian). The documents and sources of interest to this particular study are available in the old but still invaluable collection of G. Gaye, *Carteggio inedito*

d'artisti dei secoli XIV, XV, XVI, Florence, 1839–40, vols. II and III; the remarkable collection of archival material dealing with the David of 1501–04 and its predecessor of the Quattrocento is in G. Poggi, *Il Duomo di Firenze*, Berlin, 1909 (relevant documents reprinted and translated here as Appendix II-A). A still-useful biography of Michelangelo is the Condivi *Vita* of 1553 in the edition of K. Frey, Berlin, 1887; the Vasari *Vite* of 1550 and 1568 have recently been reprinted with voluminous and most valuable notes by Paola Barocchi, under the title *Giorgio Vasari, La Vita di Michelangelo nelle redazioni del 1550 e del 1568* (5 vols.), Milan-Naples, 1962 (effectively replacing the older 19th century edition of G. Milanesi). For the letters, see now the two-volume translation: E. K. Ramsden, *The Letters of Michelangelo*, Stanford, 1963; the standard edition of the letters in the original Italian is still that of G. Milanesi (Florence, 1875). I have used for the poems E. N. Girardi, ed., *Michelangelo Buonarroti, Rime* (series *Scrittori d'Italia*), Bari, 1960; the finest and most modern translation into English is Creighton Gilbert's: Gilbert and Linscott, *Complete Poems and Selected Letters of Michelangelo*, New York, 1963. Recent discussions and translations of the poems are to be found in R. J. Clements, *Michelangelo, a Self-Portrait* (Prentice-Hall) 1963; and R. J. Clements, *The Poetry of Michelangelo*, New York, 1965.

As supplement to the titles on Michelangelo given above, I have enjoyed using for Donatello's Davids the by now classic two volumes by H. W. Janson, *The Sculpture of Donatello*, Princeton, 1957 (reprinted in one volume, 1964). Among several recent studies that throw light on stylistic definitions, there are two in particular to be singled out: for the Quattrocento libertarian background, F. Hartt, "Art and Freedom in Quattrocento Florence," in *Essays in*

Notes

Memory of Karl Lehmann, ed. L. F. Sandler, New York, 1964; for the stylistic ambient of the David of 1501–04, a number of relevant passages in S. Freedberg, *Painting of the High Renaissance in Rome and Florence*, Cambridge, Massachusetts, 1961. In connection with the Florentine Neoplatonic psychology of art and the relation of genius to melancholy there is a rich literature of fairly recent date: in addition to the classic study of Dürer's Melancolia I by E. Panofsky and F. Saxl, there are excellent passages in Jean Seznec, *Survival of the Pagan Gods* (edition in English translated by Barbara Sessions), New York, 1953; passages in Andre Chastel, *Marcel Ficin et l'Art*, Geneva-Lille, 1954; and in M. and R. Wittkower, *Born under Saturn*, London–New York, 1963. A valuable recent *mise au point* of Italian Renaissance philosophical positions is P. O. Kristeller's *Eight Renaissance Philosophers*, Stanford, 1964.

83

NOTES TO CHAPTER 1

1. Louvre, no. 714 *recto;* B. Berenson, *Drawings of the Florentine Painters,* Chicago, 1938, no. 1585; C. de Tolnay, *The Youth of Michelangelo,* Princeton, 1943, no. 16.

2. C. de Tolnay, 205 ff.; documents principally in G. Gaye, *Carteggio inedito d'artisti dei secoli XIV, XV, XVI,* Florence, 1840, ɪɪ, 52–55, 58–61, 77–79, 101–03, 109.

3. Francesco Petrarca, Sonnet ᴄᴄxxvɪɪɪ. In Joseph Auslander's translation (New York: David McKay Co., 1932), the first line runs:

 The lofty Column and the Laurel fall.

 The last lines contain the poignant expression of loss:

 Ah life, that seems so rich in ecstasies
 Yet can in one swift morning dissipate
 What we have gained with years and many sighs.

 Michelangelo later closely paraphrased these last lines in a quatrain fragment.

4. Translation of John Addington Symonds. The text as set to Isaac's moving music has been recorded by the New York Pro Musica under the direction of the late Noah Greenberg (Decca, DL943).

5. Vasari mentions, as an apparent exception to the bow-handle design of the running drill, a brace and bit design invented by Alberti for cutting porphyry: see L. S. Maclehose and G. B. Brown, *Vasari on Technique,* New York, 1960 (first published in 1907), pp. 30–31. For softer marble the old-fashioned bow-drill would have presumably sufficed; drills weighing up to twenty pounds could be used, thus providing for a relatively powerful and efficient boring tool. Alternate readings of *arco* are: a weapon directed against Leonardo da Vinci in a figurative sense (Papini, in *Il Vasari,* ɪɪɪ, 1930, p. 1), as Cupid's bow (Pecchai, *ibid.,* p. 221), the curved portion of a harp-frame (R. J. Clements, *Poetry of Michelangelo,* pp. 154–160). Clements connects the

scholium with the bronze David for the Maréchal de Gié and suggests that the line is the first thought for an inscription which tradition had said was Michelangelo's, inscribed on the base of the statue when it was finally set up in the chateau at Bury in France; the verses are lost, though a transcribed translation into French at one time attributed to Ronsard still exists. Michelangelo the Younger, of rather dubious fame as editor of his great-uncle's poetry, had apparently thought the reference was to a harp. Iconographically, the type of David with the harp (psalmist) is medieval and northern as opposed to the Florentine Quattrocento freedom symbolism in the shepherd-slayer of Goliath (for the medieval David see H. Steger, *David Rex et Propheta*, Erlangen, 1961). Before Clements, J. Tusiani had associated the "bow" with music, noting the pairing of "sling and bow, stone and song" (*The Complete Poems of Michelangelo*, New York, 1960, p. 69). E. N. Girardi, however, had been more cautious and general in his interpretation: "M. vuol forse dire: Davide combatte per la forza, io con la potenza dell'ingegno," (*Rime*, Bari, 1960, p. 473). Though it begs the question, Girardi's literary-minded interpretation is still preferable to Clement's ingenious but shaky construction based on the inscription (lost) of the French pedestal (also lost) The inscription as recorded in French corresponds iconographically to the "Beatus Vir" initial illuminations in northern, particularly French, psalters. The initial B normally displayed in one compartment David as harpist and in the second David triumphant over Goliath, though sometimes David is shown being crowned King. A long series of examples is given in Leroquais' *Les psautiers-manuscrits Latins des bibliotheques publiques de France*, Macon, 1940–41, *passim*.

6. See the wording of the contract of August 16, 1501 (Appendix II-A, pp. 136-37).

7. See Appendix II-A, p. 137.

8. The best known of all the compositions of the Brancacci Chapel in the

Carmine. The topical references in the imagery have been fairly recently played down by Professor Meiss in favor of a more theological and cosmic meaning: M. Meiss, "Masaccio and the Early Renaissance: the Circular Plan," in *Acta* of the Twentieth International Congress of the History of Art, II, (Princeton, 1963). Professor F. Hartt in his "Art and Freedom in Quattrocento Florence" (in *Essays in Memory of Karl Lehmann*, New York, 1964) has stayed with the interpretation of the Tribute Money fresco as related to the *catasto*, or real-property tax of 1427 to support the war against Milan. He brings an important reference in the writings of the roughly contemporary St. Antonine to the discussion (see p. 129 in the Lehmann memorial volume). Dr. Peter Meller (in *Acropoli, I* (1961-62), pp. 186-227, 273–312) has connected the Brancacci Chapel imagery with the theme of Florentine reconciliation with the Milanese. This is the least persuasive of the three theses. However, the question is far from closed. The papal (Guelph Party) references are as strong as the republican overtones of independence in the total imagery of the Chapel.

9. Matt. 17:24–27.
10. See the various interpretations cited in note 8 above. There may well be a philosophical as well as a political and theological background to Masaccio's Tribute Money subject. The reader may be struck by "democratic" parallels in the Pre-Platonic Epicureanism as transmitted through fragments of Democritus. It is worth making a comparison with the gospel text that provides the fresco's subject:

Matt. 17:24–27	Democritus, *Aphorism* 14 (B255)
And when they were come in Capernaum, they that received tribute money came to Peter and said, Doth not your master pay tribute? He saith yes and when	At that time when the powerful [classes] confronting the have-nots take it on themselves to pay toll to them and to do things for them and to please them: This is

he was come into the house, Jesus prevented him, saying, What thinkest thou Simon?

Of whom do the kings of the earth take custom or tribute? Of their own children or of strangers?

Peter saith unto him, Of strangers. Jesus saith unto him, Then are the children free.

Notwithstanding, lest we should offend them, go thou to the sea and cast a hook, and take up the fish that first cometh up; and when thou hast opened his mouth, thou shalt find a piece of money: that take and give unto them for me and thee.

—— King James Version

the situation in which you get the [phenomenon of] compassion and the end of isolation and the creation of comradeship and mutual defense.

and then civic consensus and then other goods beyond the capacity to catalog in full.

Democritus, *Aphorism* 15 (B250)

It is consensus that makes possible for cities the [execution] of mighty works enabling them to execute and carry through wars.
—— E. H. Havelock,
The Liberal Temper in Greek Politics, New Haven, 1964, p. 142.

11. See H. W. Janson, *The Sculpture of Donatello,* Princeton, 1957, ɪ, pls. 1–6; ɪɪ, pp. 3–7.
12. I am following here Professor P. O. Kristeller's view on the eclectic nature (including large influences from Stoicism and Epicureanism) of the "pre-philosophical" humanism already in strong evidence in Florence from the time of Bruni until the Platonic revival. Note also the libertarian elements in the Florentine intellectual climate as brought out vividly by Professor Baron: H. Baron, *The Crisis of the Early Italian Renaissance,* Princeton, 1955.
13. *Phaedrus,* 252, d7.

87

14. *Enneads,* I, 6 in E. O'Brien, *The Essential Plotinus,* Mentor, 1964, p. 42.
15. See E. Panofsky's classic treatment in *Studies in Iconology,* Oxford–New York, 1939, *passim;* also A. Chastel, *Marcel Ficin et l'Art,* Geneva-Lille, 1954, *passim.*

NOTES TO CHAPTER 2

1. The core of this chapter consists of material presented mainly in different form at the Twenty-First International Congress of the History of Art, at Bonn in September, 1964. I am endebted to Professor de Tolnay for encouraging me to work up the material for presentation at the Congress and to Professors von Einem and Kauffmann at the University of Bonn for courtesies in connection with the publication in the *Acta* and permission to include certain portions of my first text here. Meanwhile, this spring (1967) Mrs. Virginia Mockler has submitted to Columbia University her doctoral dissertation on the colossal mode in Italian Renaissance statuary. This is a fine piece of work and covers independently and more fully in some cases material in this and the following chapter.
2. See the most recent annotated edition by Paola Barocchi *Giorgio Vasari, La Vita di Michelangelo, etc.* (cited in the General Bibliographical Note), I, pp. ix–xlv.
3. Barocchi, I, pp. 19–23.
4. In Varchi's well-known lectures to the Academy in Florence on Michelangelo's esthetic as expressed in the sonnet, "Non ha l'ottimo artista alcun concetto," published as *Due Lezioni,* Florence, 1549.
5. The document is of May 6, 1476 (Poggi, 446); given in full in Appendix II-A, p. 134.
6. The payment clause in the contract called for 6 florins monthly for two years; this sum corresponds to what would have been paid in 1466 had the statue been completed then. The terms were changed in 1502

to a flat sum of 400 florins to be paid in full on the statue's completion. The sculptor drew no less than six advances between March 5, 1502, and June 20, 1503.

7. E. Panofsky, *Renaissance and Renascences in Western Art*, Stockholm, 1960, p. 152, fig. 113. In the recently published (1964) report on the cleaning of the fresco by Tintori and Eve Borsook, the motifs of the statuary are reported as authentic: *Giotto, The Peruzzi Chapel*, New York, 1964, pls. 47-49.

8. For the Milanese figures see U. Nebbia, *La Scultura nel Duomo di Milano*, Milan, 1908, *passim*. For the David which has usually been attributed to the years 1408–09 and to Donatello, see H. W. Janson's clear analysis in *The Sculpture of Donatello*, II, pp. 3–7. At the Donatello Congress held in Florence in September, 1966, Manfred Wundram argued for acceptance of the prophet now usually given to Nanni di Banco as the Donatello prophet of the documents of 1408–09. The Wundram thesis is a restatement on newly defined grounds of an older attribution advanced as early as 1875 by Semper. The idea, though courageously presented, still needs testing.

9. B. Shaw, in *Mitteilungen des Kunsthistorischen Instituts in Florenz*, 1959, pp. 178 ff.

10. Joshua, 1:6.

11. Cited by C. de Tolnay, *The Youth of Michelangelo*, Princeton, 1943, pp. 197–98. The Hercules theme was incorporated in Michelangelo's lost statue of 1493–94 last traced to Fontainebleau, as de Tolnay has stressed in his recent reworking of the material in *The Art and Thought of Michelangelo*, New York, 1964; a drawing in the Louvre attributed to Rubens has been interpreted by de Tolnay as after the statue while it was still visible in the gardens at Fontainebleau.

12. *Historia Naturalis*, XXXIV, 18.

13. See Appendix II-A, p. 117. The document is of October 16, 1449 (Poggi, 329).

14. The so-called David II, to which Lányi had called attention. It is a commission which fits perfectly into the Duomo Prophet-sequence as we can reconstruct it today. However, the interpretation of the documents and the identification of the piece today offer thorny problems. For a summary discussion of the problems see Appendix I.
15. Quoted from E. H. Richardson, *The Etruscans*, Chicago, 1964, p. 91.
16. J. R. Spencer, tr., *Alberti on Painting*, Oxford–New Haven, 1956, p. 39.
17. For Ghiberti on the lore of Antiquity in sculpture see the authoritative chapters in R. Krautheimer, *Lorenzo Ghiberti*, Princeton, 1956. Colossi are mentioned in Ghiberti's own text twice: see O. Morisani, ed., *I Commentari*, Naples, 1947, pp. 23–24. Alberti also treated the lore of colossi from the Egyptians through to Rome in *De Re Aedificatoria* (Book VII).
18. A report of 1525 mentioning Donatello as the artist entrusted with the marble colossus finished by Michelangelo is published in G. Gaye, *Carteggio inedito d'artisti dei secoli XIV, XV, XVI*, Florence, 1840, ɪɪ, p. 465.
19. See H. W. Janson, "Giovanni Chellini's 'Libro' and Donatello," in *Studien zur Toskanischen Kunst: Festschrift fur L. H. Heydenreich*, ed. W. Lotz and L. L. Moller, Munich, 1964, pp. 131–38.
20. Appendix II-A, pp. 122-25. The document is of April 16, 1463 (Poggi, 437).
21. What this "node" actually was is not known with certainty. Conceivably it might have been a "knot of drapery" or a "nodule" or "flaw" in the marble. However, Professor Irving Lavin has set forth the more persuasive theory that it was a location-point or pointing-reference left from Agostino di Duccio's preliminary carving of the statue in 1464–66; Michelangelo by striking it off was then symbolically asserting his independence from his predecessors and their methods. Professor Lavin's discussion is included in the *Acta* of the Twenty-First International Congress of the History of Art, Berlin, 1967, ɪɪɪ, pp. 93-104.

NOTES TO CHAPTER 3

1. Translation modified from that of E. L. Forbes based on the Italian edition of E. Garin (Lexington, 1953).
2. *Alberti on Painting*, ed. J. R. Spencer, Oxford–New Haven, 1956, p. 63.
3. See P. F. Norton, in *Art Bulletin*, xxxix (1957), pp. 251–57.
4. *Historia Naturalis*, xxxiv, 41: "... pauci pollicem eius amplectuntur. Maiores sunt digitae quam pluraeque statuae...." Pliny also cites a Tuscan Apollo "Tuscanicem Apollonem" among his colossi.
5. See R. Krautheimer, in *Lorenzo Ghiberti*, Princeton, 1956, p. 280, n. 12.
6. Given in Alberti's *De Statua* as an appendix, and to be dated accordingly as just before the *Della Pittura* of 1435–36.
7. Professor Hans Kauffmann had earlier established the relationship of the proportions of Donatello's bronze David with the Albertian system as continued by Leonardo (*Donatello*, Berlin, 1935, pl. 28). Kauffmann's date of *c.* 1460 is no longer considered tenable (cf. Janson below); instead the bronze David must be placed in the 1430's, possibly in 1435, in other words, just after Donatello's return from Rome. The new dating strengthens the hypothesis of a connection in Rome between Alberti and Donatello.
8. H. W. Janson, *The Sculpture of Donatello*, Princeton, 1957, i, pls. 39–46.
9. See Sartre's famous lecture, *L'Existantialisme est un humanisme* (1946), published in America as *Existentialism*. The title in the original is an important index to the direction of Sartre's thought at the time. There are numerous parallelisms to Pico's thesis: "We will to exist, as we fashion our image," for only one example. Professor Kristeller has noted the apparent connection between Sartre and Pico, but tends to discount the existentialist aspects *avant-la-lettre* in the *Oration* of 1486. The controversial topic could still be re-examined with profit.
10. See K. Jex-Blake and E. Sellers, *The Elder Pliny's Chapters on the History of Art*, London–New York, 1896, pp. 15–35.

11. The best illustrations still are in C. de Tolnay, *The Youth of Michelangelo*, Princeton, 1943, pls. 17–20.

12. For Saturn's role in the production of human *ingegno* there is a wealth of perceptive studies including the work of Panofsky, Saxl, Chastel, and quite recently (see note 13) Rudolph and Margot Wittkower, and F. Nordstrom (*Goya, Saturn, and Melancholy*, Stockholm, 1962). Ficino's views on the relation of freedom and restriction of the individual will in "Saturn's children" is beautifully set forth in Professor Jean Seznec's classic study, *The Survival of the Pagan Gods*, New York. I owe Seznec a great deal in discussion of these points in Pittsburgh in the winter of 1965.

13. R. and M. Wittkower, *Born under Saturn*, London, 1963, p. 68.

14. See particularly C. de Tolnay, *The Art and Thought of Michelangelo*, New York, 1964, *passim*, and in the *Acta* of the Twenty-First International Congress of the History of Art, Berlin, 1967.

15. F. Gilbert, "Florentine Political Assumptions in the Period of Savonarola and Soderini," *Journal of the Warburg and Courtauld Institutes*, xx (1957), pp. 209–10,212.

16. Walters Art Gallery, Baltimore, Maryland, attributed to Luciano Laurana.

17. In "Die Michelangelo Literatur Seit 1914," in *Jahrbuch für Kunstgeschichte*, Vienna, I (1921–22), p. 27. The opposing theory, that the sculptor preferred the final position near the Palazzo entrance, is most fully treated in C. Neumann, "Die Wahl des Platzes für Michelangelos David in Florenz im Jahr 1504," *Repertorium für Kunstwissenschaft*, xxxviii (1916), pp. 1 ff.

18. The "Michelangelo" cited in the report of the inquiry was not the young sculptor but a goldsmith, Michelangelo Bandinelli, father of the sculptor Baccio Bandinelli. See Appendix II-B.

19. Appendix II-B, pp. 146-47.

20. Appendix II-B, pp. 150-51.

21. Appendix II-B, pp. 154-55.

NOTES TO CHAPTER 4

1. Paraphrase in free verse from no. 68 of E. N. Girardi's edition (Bari, 1960) of the *Rime;* variant of the published translation by Professor Creighton Gilbert.
2. See notes 12 and 13 of Chapter Three.
3. Quoted by A. Chastel, *L'Art et l'humanisme à Florence au temps de Laurent le Magnifique,* Paris-Lille, 1959, p. 209.
4. Letter of October, 1525: R. J. Clements, *Michelangelo, a Self-Portrait,* Prentice-Hall, 1963, p. 35.
5. Girardi, ed., *Rime,* no. 68, pp. 38–39.
6. *Ibid.,* no. 67, pp 34–35. "Why?" and "Perhaps" *(El Come e'l Forse)* are characterized interestingly enough as giants. These verses are sometimes interpreted as reference to a general apocalypse, but the meaning as referring to Medicean Florence is clearer.
7. Sir K. Clark, ed., *A Catalogue of the Drawings of Leonardo da Vinci in the Collection of His Majesty the King at Windsor Castle,* New York–Cambridge, 1935, nos. 12376–87.
8. *Lucretius on the Nature of the Universe,* tr. R Latham, Penguin-Baltimore, 1964, p. 234.
9. *Ibid.,* p. 174.
10. E. McCurdy, *The Notebooks of Leonardo da Vinci,* New York, 1938, I, p. 80.
11. W. Stechow, "Joseph of Arimathea or Nicodemus?" in *Studien zur Toskanischen Kunst: Festchrift fur L. H. Heydenreich,* ed. W. Lotz and L. L. Moller, Munich, 1964, pp. 289–302.
12. John, 19:39.
13. *King Lear,* Act IV, sc. 1, ll. 18–19.
14. Now at Milan, Museo del Castello Sforzesco; formerly in the Rondanini Palace in Rome, whence the title Rondanini Pietà under which it continues to be known.

Appendix

I

Donatello's Second David for the Duomo

THE analysis given here is for specialists' eyes, and even then only if the reader has enough patience to thread his way through an unusually dense undergrowth of documentation and argument. The conclusion that is reached is that the mysterious marble commissioned of Donatello in 1412, which must have been intended as substitute for his first David (or David I) of 1408–09, probably never got beyond the first stage of rough blocking out. The reasons for this negative conclusion follow below, and are drawn from documents in the archives of Florence Cathedral, originally published by Giovanni Poggi and given in chronological order in Appendix II-A. The figures following "Poggi" in parentheses refer to his document numbers.

From this available documentation, it is known that:

a) Donatello was to receive a total payment of 128 florins for the successor to his marble David of 1408–09 (David I), namely, the terracotta Joshua (Poggi, 420).

b) Donatello was to receive a total payment of 160 florins for the contemporaneous St. John Evangelist for the façade (1408–1415) (Poggi, 220).

Payments to Donatello that were finally credited to his account for the St. John may be listed as:

18 April 1413 (Poggi, 206)	fl. 30
21 February 1415 (Poggi, 211)	15
10 May 1415 (Poggi, 216)	20
3 June 1415 (Poggi, 218)	35
8 October 1415 (Poggi, 220), closing account	60
Total	fl. 160

From this accounting it seems apparent that the Operai counted advances on the Evangelist as part of its actual payment from only April 18, 1413, on. Early advances on the Evangelist were evidently counted instead in relation to the other two concurrent projects: a second David and the Joshua.

On the other hand, it must be recognized that advances to Donatello on the Joshua were mixed in the records with advances on the Evangelist, and occasionally, it would seem, with other work, which has been connected with the second marble David (David II). It is not possible therefore to give a simple accounting for the Joshua figure as was done for the Evangelist. It is necessary instead to begin with all payments or loans on account made out to Donatello within the critical period between June 13, 1409, when the David I account was closed, and August 12, 1412, when the Joshua account was closed. The listing is as follows:

1. July 27, 1409 (Poggi, 175) ("pro parte solutionis figure quam facit"). Comment: May refer to either Evangelist or Joshua. fl. 20

2. November 13, 1409 (Poggi, 177) ("pro parte solutionis plurium figurarum marmorearum"). Comment: May refer to combination of Evangelist and Joshua and David fl. 30

	II, or simply to Evangelist and Joshua.	
3. November 18, 1409 (Poggi, 178)	*(ut supra).* Comment: May conceivably represent a correction of the amount agreed Nov. 13 in Poggi 177 as shown in item 2 above.	fl. 20
4. October 19, 1411 (Poggi, 194)	("pro una figura quam figura quam facit pro parte solutionis"). Comment: May refer to Evangelist just as well as to David II. This loan also recorded as of December 24, 1411 (Poggi, 195).	fl. 10
5. July 27, 1412 (Poggi, 419)	("pro parte solutionis dicte figure" [i.e. "Josue"]). Comment: For Joshua alone. Refers to repetition of a payment of June 28, 1412, on July 27, 1412, for painting "Giesue" (Josue), as given in Poggi, 417 and 418.	fl. 50
6. August 12, 1412 (Poggi, 420)	("habere debeat pro pretio sui laboris in faciendo figuram josue ... in totum fl. cxxviii"). Comment: Clearly closes Joshua account at sum total of 128 florins.	
7. August 12, 1412 (Poggi, 199)	("pro figura S. Johannis Evangeliste et Davit pro eius magistro et pictura ... non intelligatur quod	fl. 50

99

paga fienda magisterii et marmi albi dicte opere in aliquo deficiat"). Comment: May duplicate payment for Joshua of same amount of July 27 but this does not seem likely. (See item 4 above.) This advance certainly seems to include money for marble to be purchased and appears to open a new account for a "Davit" (i.e. David II).

The total of the sums advanced as shown above is not immediately clear. Depending on whether the loans of November 13 and 18, 1409, are considered as independent or, on the contrary, the latter entry is considered a correction of the first, there may be a difference of as much as 30 florins in the advanced total. The maximum total is 180 gold florins, the minimum, 150.

The maximum total of 180 gold florins is the one to be assumed, as will be seen. As of August 12, 1412, a picture of the situation does indeed emerge from the documents. It appears clear that the Joshua account was closed on that day and a new account for a David of white marble was opened and 50 florins advanced which were to include the purchase of the marble for the projected statue. If 50 is subtracted from the maximum total of 180 florins advanced, the remainder is 130 or almost exactly the sum of 128 florins, as shown in item 6 above, which was determined as the total payment due the sculptor on the Joshua.

The arithmetic up to this point makes sense. If we review the accounting entries there is therefore no reason to believe

that the loans made to Donatello between June 13, 1409, and August 12, 1412, were anchored to work actually being done on any figures except the Evangelist and the Joshua. Too literal an interpretation of the reference to marble as material for the "figurae" is to be avoided. If the Joshua is mentioned in the accounts as a marble, as in item 2 above, it was likely to be simply because it was being grouped in the minds of the Operai for convenience with the marble Evangelist; marble could have been used in the language of the accounting entry as an inclusive generic, not as a specifying, restrictive term.

The decision to advance 50 florins to Donatello on a new "Davit" (David II) was worded in the document of August 12, 1412, in such a way as to indicate that some future dispute might arise as to whether the sum was sufficient to cover all expenses, both the working expenses of the sculptor and the cost of moving the marble to Florence after being blocked out at the quarry. Presumably the payment for the marble itself was to have come from a separate account on delivery to the Opera. In any event the document of August 12, 1412, deals with concern for the future; it cannot be interpreted as referring to work already in progress except in the case of the Evangelist.

We may start now to move toward a conclusion. After August 12, 1412, there is no further mention in the documents of the Duomo of the "Davit" apparently commissioned as of that date from Donatello. But there is no reason to doubt that a partially blocked out piece of marble was delivered from Carrara to the Opera at some slightly later date. It is possible also to think that some of the concern about the sufficiency of the advance of 50 florins to Donatello in this connection was due to plans to acquire

101

a more than normally sized block, somewhat over life-size, so that the finished figure would carry visually from its planned emplacement with more success than the Isaiah by Nanni di Banco or the David I of 1408–09 by Donatello. The silence of the documents on the subject after its introduction indicates that Donatello did nothing on the David II except preliminary roughing out provided for in August of 1412. In 1412–13, it must be recalled, he was busy with the St. Mark for Or San Michele, and starting with April 18, 1413 (Poggi, 206), the documents show he was beginning to attack his Evangelist for the Duomo in earnest; this large figure was actually completely finished under pressure and threats of a heavy fine by October 1415.

It is conceivable that the block for the David II languished untouched in the Opera shops until it was used for another statue. There is an undocumented (*pace* Siebenbühner, on the basis of Wundram's careful research) possibility that it could have been sold to the Armorers' Guild in 1415 or after for the over-life-size statue of St. George commissioned at about this time from Donatello. As pointed out by Janson, there are serious objections to any theory that the St. George was a warmed-over adaptation of an earlier, nearly completed David figure.

But the same reasoning also weakens another theory (proposed by Janson on the basis of an earlier theory of Clarence Kennedy's) that the David II has survived in a much later reworked form in the Martelli David, now in the National Gallery in Washington. In the first place, the slight scale of the Martelli David is wrong for the projected Duomo Prophet-series. And there is also an objection that should be made to the assumption that Donatello kept the hypothetical David II for his own experi-

mental use. How is it possible to imagine that a Duomo sculptor of 1412 would be permitted to go off with a half finished marble in order to work it over at indefinite intervals, during a period of decades perhaps? It would have been in any case Duomo property, even unfinished.

Less far-fetched is the theory published by Valentiner on an idea earlier discussed by Ulrich Middeldorf as a working hypothesis that the David II was adapted by Nanni di Bartolo (called "Il Rosso") to make the so-called Young Baptist of the Campanile series. It must be recalled, however, that the Duomo Prophet-series of which the David II was to have been a part would have required not a young shepherd-David so much as a "David-profeta," and the open stance and youthful type of Rosso's "Prophet" (which it must have been intended to represent originally before being labeled as a "Baptist") would not necessarily have been found in the David II. It would seem then, as felt by the older scholarship to which Janson has returned, that the pose of the Baptist of the Campanile followed rather than anticipated the St. George.

Conclusions: On balance, then, the least objectionable of the available theories is that which supposes that the block which the Duomo Operai had intended for a "Davit" in 1412 was sold, possibly to the Armorers in 1415, possibly later. As far as actual sculpture is concerned, Donatello's David II seems never to have left the block. It was probably never anything more than a projected statue.

A supposed sale of the marble block in 1415 had another corollary. It meant that the scheme of 1412 to continue the Duomo Prophet-series in over-life-size marble (even then not at the

colossal scale possible in terracotta), was at least momentarily abandoned.

A new solution was by then already in the making. It originated, it would seem, in the fertile mind of Filippo Brunelleschi. This was to make a large figure by sheathing a core, or solid armature, with lead sheets, and for protection against the weather to be gilt *all'antica* in the Roman colossal mode, reminiscent of the accounts of the Colossus of Rhodes. In 1415, precisely, there is a trustworthy record that Donatello and Brunelleschi intended to present to the Operai a model illustrating this pseudo-Rhodian solution to the problem of the Tribuna Prophets: "per pruova e mostra delle figure grandi che s'anno a fare in su gli sproni di Santa Maria del Fiore" (Poggi, 423, date of October 9, 1415).

The sale of the David I of 1408–09 to the Priors of the Commune of Florence within the year (Poggi, 425, date of July 6, 1416) is a further indication that the original Trecento idea of using marble statuary for the *sproni* was in eclipse. Actually in 1415 attention had turned as far as marble sculpture for the Duomo was concerned to the upper façade and the Campanile. Only Donatello's huge painted terracotta Joshua on the north Tribuna, the *homo magnus et albus*, remained in place as a reminder of unfinished business. The way is now cleared for a fresh consideration of the "Hercules" and David (David III) of the 1460's which recent research indicates was based on Donatello's design and inspiration though executed under his direction by Agostino di Duccio (see pp. 55–58). This David of course became "Michelangelo's David."

Appendix

II

Archival Documentation with Translation

Appendix II-A
Programmatic prehistory of the David of 1501–04

THE following documents have been selected from Giovanni Poggi's edition of the minutes of the overseers (Operai) of the Florentine Duomo, published in *Il Duomo di Firenze* (Berlin: Bruno Cassirer, 1909). In parentheses are document numbers and sources with the abbreviations used by Poggi. His editorial interpolations are also in parentheses. The English translation is by Paul Watson. It is intended to be as literal as possible in order to provide a convenient tool for learning to read this kind of archival text.

The basic unit of measurement, the Florentine *braccio*, is usually considered equivalent to 22⅞ inches. There are 20 soldi in each lira and 12 denari in each soldo. The relation of the lira to the florin fluctuated somewhat; at this time it was roughly 4 to 4¼ lire to the florin (gold). The *fiorino di suggello* (mentioned in item 29) was worth less than the *fiorino d'oro*, at a ratio of about 5 to 4.

Because of the damage to the Archivio dell'Opera del Duomo caused by the flood of November 4, 1966, it proved impossible to collate, as had been intended, Poggi's printed text against

the original documents. A photograph of the original page containing the text of the contract of 1501 was generously made available by Professor Irving Lavin; in this case Poggi's version was found to be entirely accurate in every detail. Small changes from the original and a few minor errors may well be found in Poggi's work. But earlier spot-checks do not bear out any assumption that they come from serious omissions or misreadings. They would probably not affect in any essential way the historical issues discussed in this volume. Nevertheless the author regrets exceedingly the circumstances beyond all control that prevented what would be a normal measure of editorial precaution.

1. (405) 1408, January 24.

Deliberaverunt quod fiat unam figuram nominis Ysaie profete, marmi, longitudinis brachiorum trium et quarti unius, manu Antonii Banchi et Johannis eius filii, pro eo pretio quod videbitur et placebit supradictis operariis vel suorum successorum (!) pro tempore existentium (*Delib.*, LIV, c. 11t.)

2. (406) 1408, February 20.

Item deliberaverunt quod Donatus Betti Bardi possit...pro dicta ecclesia edificare seu facere unam figuram de uno duodecim profetis ad honorem David profete, cum modis et condictionibus pactis et salario olim factis cum Johanne Antonii Banchi, magistro unius figure per eum accette ad construendum pro quodam alio profeta, que poni debeant super spronis unius tribune que ad presens edificata seu completa consistit. (*Delib.*, LIV, c. 15t.)

1. (405) 1408, January 24.

It was decided to commission a figure of the prophet named Isaiah, to be of marble and three and a quarter *braccia* high, by the hand of Antonio di Banco and his son Giovanni [Nanni di Banco]; the price is to be decided as it may please the aforesaid *operai* or their successors during their term of office. (*Delib.*, LIV, folio 11 verso.)

2. (406) 1408, February 20.

Item. It was decided that Donato di Betto Bardi [Donatello] was competent... to make or execute for the said church one of the figures of the twelve prophets, to wit the prophet David, under the terms and conditions, and for the same salary, as those concluded with Giovanni d'Antonio di Banco, the master in charge of a figure that he has agreed to make as a certain other prophet, which is to be placed upon the buttress of one of the tribunes at present built or completed. (*Delib.*, LIV, folio 15v.) 109

3. (407) 1408, June 21.

Donato Niccolai Becti Bardi, civi florentino, magistro intagli figurarum marmorearum dicte opere, pro parte solutionis sui salarii et mercedis laborerii facti et fiendi in dictis figuris, fl. x au. (*Delib.*, LV, c. 28.)

A Donato di Niccolò di Betto Bardi in prestanza sopra una figura ch' egli intaglia, f. x d'oro. (*Stanz.*, QQ, c. 24t.)

4. (408) 1408, September 11.

Donato Niccolai Becti Bardi, intagliatori figurarum marmorearum, pro parte solutionis sui laboris indulti et indulcendi in dictis figuris dicte opere, fl. xv au. (*Delib.*, LV, c. 29t.)

5. (409) 1408, December 15.

Donato Nicholai Betti Bardi, pro parte pretii figure marmoree per eum facte seu quam facit, fl. xxiv au.

Antonio Banchi, lastraiuolo, pro pretio figure marmoree facte per Johannem eius filium, in totum fl. lxxxv au. (*Delib.*, LVI, c. 4t.)

6. (410) 1409, March 27.

Donato Niccolai, intagliatori, pro parte intagli figurarum quas facit, fl. xv au. (*Delib.*, LVII, c. 2t.)

7. (411) 1409, June 13.

Deliberaverunt quod Donatus Nicolai Betti Bardi, de figura per ipsum facta de quodam profeta, habeat fl. c au., et quod

3. (407) 1408, June 21.

To Donato di Niccolò di Betto Bardi, citizen of Florence and a master charged with carving marble statuary for the said Opera [del Duomo], as partial payment of his salary and fees, for work completed and being completed toward the said figure(s), 10 gold florins. (*Delib.*, LV, folio 28.)

To Donato di Niccolò di Betto Bardi in payment for a figure that he is carving, 10 gold florins. (*Stanz.*, QQ, folio 24v.)

4. (408) 1408, September 11.

To Donato di Niccolò di Betto Bardi, sculptor of marble figures, as partial payment for work done and still being done on the said figure(s) for the said Opera, 15 gold florins. (*Delib.*, LV, folio 29v.)

5. (409) 1408, December 15.

To Donato di Niccolò di Betto Bardi, as partial payment for a figure of marble that he has made and is still making, 24 gold florins.

To Antonio di Banco, sculptor, as payment for a marble figure made by his son Giovanni, 85 gold florins in all. (*Delib.*, LVI, folio 4v.)

6. (410) 1409, March 27.

To Donato di Niccolò, sculptor, for part of the carving of the figure(s) that he is making, 15 gold florins. (*Delib.*, LVIII, folio 2v.)

7. (411) 1409, June 13.

It was decided that Donato di Niccolò di Betto Bardi should have 100 gold florins on account for a figure of a certain prophet

111

camerarius de pecunia dicte opere pro residuo det et solvat, deductis habitis, pro ipsius residuo Donato predicto, fl. xxxvi au. (*Delib.*, LVII, c. 7t.)

8. (412) 1409, June 14.

Deliberaverunt quod camerarius det et solvat Christoforo Bernardi et sotiis qui extimaverunt figuram profete factam per Donatum in totum, ad rationem s. xx pro quolibet, l. vi fp. (*Delib.*, LVII, c. 8.)

9. (413) 1409, July 3.

Deliberaverunt quod figura profete posita ad cupolam elevetur et ponatur in terram. (*Delib.*, LVII, c. 10t.)

10. (414) 1410, August 27—September 1.

A dì detto (*Agosto 27*) al Chiaro di Michele per 8 chiavatori per fare la chiusa alla figura della terra chotta, l. IV.—A dì l di Settembre per 2 castagni per fare la chiusa alla figura della terra, l. I s. II. (*Stanz.*, QQ, c. 39.)

11. (415) 1410, December 12–24.

A dì detto (*Dicembre 12*) per un pezo di macigno comperò Brunaccio per la figura della terra da Nofri lastraiuolo.—A dì 24 di Dicembre per lb. 82 d'olio di lino seme e lb. 3 di vernice liquida e lb. 30 on. 3 di biaccha s'ebe da Antonio e Giuliano di Pierozo speziali per tutto f. III l. VIII s. II d. IV p. tolsensi le dette cose per la figura della terra chotta di su lo sprone. (*Stanz.*, QQ, c. 41.)

that he has made; the treasurer of said Opera is to render and pay unto the said Donato 36 gold florins as the remainder of the sums owed to him. (*Delib.*, LVII, folio 7v.)

8. (412) 1409, June 14.

It was decided that the treasurer should award and give to Cristoforo di Bernardo and to the others who have evaluated a figure of a prophet made entirely by Donato the sum of 6 lire, calculated at the rate of 20 soldi each. (*Delib.*, LVII, folio 8.)

9. (413) 1409, July 3.

It was decided that a figure of a prophet which had been put up by the dome should be removed and put back on the ground. (*Delib.*, LVII, folio 10v.)

10. (414) 1410, August 27–September 1.

On this day, the 27th of August, to Chiaro di Michele, for eight "keys" used to close up the figure of terracotta, 4 lire.

On this day, the 1st of September, for two hinges [literally "chestnuts"] used to close the figure of terracotta, 1 lira, 2 soldi. (*Stanz.*, QQ, folio 39.)

11. (415) 1410, December 12–24.

On this day, the 12th of December, for a piece of sandstone purchased by Brunaccio from Nofri the stonemason, for the figure of terracotta....

On the 24th of December, for 82 pounds of linseed oil, and for three pounds of liquid *vernice,* and for 30 pounds, 3 ounces of whiting obtained from the apothecaries Antonio and Giuliano di Pierozzo, 3 florins, 8 lire, 2 soldi, 4 denari in all: the said materials

113

12. (416) 1411, January 15.

Bernabane Michelis, pro decem diebus quod stetit ad inbia-handum quadam figura magia cotta posita super a(*n*)gulum que vadit versus ecclesia s. Marie Servorum, l. x fp. pro suo labore. (*Delib.*, LX, c. 9t. — G. 459.)

13. (417) 1412, February 9.

Item deliberaverunt quod ille homo magnus et albus qui positus est supra ecclesiam sancte Reparate albetur de giesso. (*Delib.*, LXII, c. 13t.)

Bernabe Michelis, facit tavolas giessi, habuit in mutuo pro ingiessando hominem magnum positum supra ecclesiam s. Repa-rate, l. VIII fp. (*Delib.*, LXII c. 31.)

A Bernaba di Michele, fa le tavole del giesso, in prestanza per ingiessare l'uomo grande della terra, l. VIII (*Stanz.*, QQ, c. 49t.)

14. (418) 1412, June 28.

A Bernaba di Michele per ingiessare e'mbiacchare la figura di Giesuè ch'(*e*) in sullo sprone delle mura dell' opera l. IV p. (*Stanz.*, QQ, c. 58t. — *Lo stanziamento è registrato anche nelle Delib.*, LXIII, c. 32, *ma con la data del 17 Luglio:* Bernabe Miccaelis pro ingessando et imbiaccando figuram Josue que est . . . (*!*) l. IIII.)

15. (419) 1412, July 27.

Donato Niccolai, pro figura Jesue, pro parte solutionis dicte figure, fl. L. (*Delib.*, LXIII, c. 33.)

being required for the figure of terracotta on the buttress. (*Stanz.*, QQ, folio 41.)

12. (416) 1411, January 15.

To Barnaba di Michele, for the ten days that he has spent on whitening a certain figure of terracotta placed above the corner that faces toward the church of S. Maria dei Servi, 10 lire in all for his labor. (*Delib.*, LX, folio 9v.)

13. (417) 1412, February 9.

Item. It was decided that that white colossus which has been put into position on the church of S. Reparata should be coated with whiting. (*Delib.*, LXII, folio 13v.)

Barnaba di Michele, who makes panels of gesso, should have as payment for putting gesso on the colossus placed above the church of S. Reparata 8 lire in all. (*Delib.*, LXII, folio 31)

To Barnaba di Michele, who makes panels of gesso, in payment for putting gesso on the colossus of terracotta, 8 lire. (*Stanz.*, QQ, folio 49v.)

14. (418) 1412, June 28.

To Barnaba di Michele for putting gesso on and whitening the figure of Joshua which is on the buttress above the wall of the building, 4 lire. (*Stanz.*, QQ, folio 58v.)

The payment is also recorded in *Delib.*, LXIII, folio 32, but with the date as July 17: "To Barnaba di Michele for putting gesso on and whitening the figure of Joshua which is . . . 4 lire."

15. (419) 1412, July 27.

To Donato di Niccolò, for the figure of Joshua, and as partial payment for the said figure, 50 florins. (*Delib.*, LXIII, folio 33.) 115

16. (420) 1412, August 12.

Deliberaverunt quod Donatus Niccolai Bartoli (*!*) pictor (*!*) habere debeat pro pretio sui laboris in faciendo figuram Josue, que posita est super dicta ecclesia s. Reparate, in totum pro eius labore et magisterio et expensis per eum factis, in totum fl. cxxviii au. (*Delib.*, lxiii, c. 9t.)

17. (421) 1412, September 1.

Giuliano di Pierozzo, speciale, de' avere per lb. 38 di biaccha a s. iii lb., e per lb. 33 d'olio di lino seme a s. v lb., avemo dette cose fino a dì 4 di Giugno 1412 per imbianchare la fighura di Giesue di terra è 'n sullo sprone verso i cassettai, monta per tutto l. xiii s. xiv d. iv. (*Stanz.*, QQ, c. 61.)

18. (423) 1415, October 9.

Filippo di ser Brunellesco, orafo, e Donato di Nicholò di Betto Bardi, intaglatore, voglono per parte di pagamento d'una figuretta di pietra, vestita di piombo dorato, deono fare a petizione degl' operai per pruova e mostra delle figure grandi che s'anno a fare in su gli sproni di santa Maria del Fiore, fiorini x d'oro. (*Stanz.*, QQ, c. 103.)

Donato Niccolai Betti Bardi et Filippo ser Brunelleschi, intaglatoribus, pro parte solutionis cuiusdam figure marmoris vestite plumbi aureati, fl. x au., quam facere debent pro opera. (*Delib.*, lxviii, c. 36.—G. 473.)

19. (424) 1416, January 29.

Item deliberaverunt quod precipiatur Pippo ser Brunelleschi, pro eorum parte, quod hinc ad per totam diem quintam mensis

16. (420) 1412, August 12.

It was decided that the painter Donato di Niccolò Bartoli [sic] should have as payment for his labor in making the figure of Joshua, which is placed above the said church of S. Reparata, in all, for his labor and craftsmanship and expenses contracted by him, the sum of 128 gold florins. (*Delib.*, LXIII, folio 9v.)

17. (421) 1412, September 1.

To the apothecary Giuliano di Pierozzo, for providing 38 pounds of white at 3 soldi per pound, and for 33 pounds of linseed oil at 5 soldi per pound, the said materials having been provided on June 4, 1412, for whitening the figure of Joshua in terracotta which is on the buttress facing toward the casket-makers' quarter [?], in all 13 lire, 14 soldi, 4 denari. (*Stanz.*, QQ, folio 61.)

18. (423) 1415, October 9.

The goldsmith Filippo di Ser Brunellesco and the sculptor Donato di Niccolò di Betto Bardi request 10 gold florins as partial payment for a little figure of stone, clad in lead gilt, which has been made at the request of the Operai as a demonstration and test for large figures which are to be made for placing on the buttresses of S. Maria del Fiore. (*Stanz.*, QQ, folio 103.)

To the sculptors Donato di Niccolò di Betto Bardi and Filippo di Ser Brunellesco, as partial payment for their marble figure sheathed in lead gilt which they have to make for the Opera, 10 gold florins. (*Delib.*, LXVIII, folio 36 — G. 473.)

19. (424) 1416, January 29.

Item. It was decided that Pippo di Ser Brunellesco should be warned for his own benefit that, within a period extending from

Februarii proxime futuri det et tradat Donato Betti Bardi plumbum pro prohiciendo figuram in forma eis locatam; alias, elapso termino, capiatur ad petitionem dictorum operariorum et sine ipsorum deliberatione non relapsetur. (*Delib.*, LXIX, c. 34.—G. 475.)

20. (425) 1416, July 6.

Predicti operarii (*opere s. Marie del Fiore*) considerato quodam bullettino eis trasmisso per magnificos dominos dominos priores artium et vexilliferum Justitie populi et communis Florentie de presenti mense Julii, in quo continetur in effectu quod dicti operarii teneantur mictere ad palatium et in palatio dictorum dominorum quandam figuram marmoream David existentem in dicta opera, omnibus sumptibus et expensis dicte opere, omni mora et dilatione postposita, de quo quidem bullectino apparet manu ser Ricciardi Pieri, notarii dictorum dominorum sub die secundo Julii presentis 1416 indictione nona: volentes parere mandatis dictorum dominorum... deliberaverunt quod Johannes capudmagister et Franciscus de Mannellis, provisor dicte opere, possint mictere ad palatium et in palatio predicto dictam figuram marmoream. (*Delib.*, LXX, c. 33t.)

21. (426) 1416, August 27.

Donato Niccolai Betti Bardi, intagliatori figurarum, pro pluribus diebus quibus stetit una cum aliis eius discipulis in aptando et perficiendo figuram Davit, que destinata fuit per dictos operarios in palatium dominorum priorum artium, de precepto dictorum

this day until the 15th of February in the near future, he is obliged to give and deliver unto Donato di Betto Bardi lead for making the figure in the manner agreed upon. Otherwise, if the period elapses without anything being done, it will be confiscated at the request of the said Operai, and will not be returned without their consent. (*Delib.*, LXIX, folio 34. — G. 475.)

20. (425) 1416, July 6.

The aforesaid Operai of the Opera of S. Maria del Fiore have discussed a certain message sent to them by the most noble Signoria, that is, their excellencies the Priors of the Guilds and the Gonfaloniere of Justice of the People and Commune of Florence, dated in the present month of July, in which it is found, in effect, that said Operai should order that a certain marble figure of David at present owned by the Opera be sent to and installed in the palace of said Signoria, without any delay or postponement, and with all costs and expenses to be defrayed by said Opera; the message was delivered by the hand of Ser Ricciardo di Piero, notary of the said Signoria, on the 2nd of July 1416 at the ninth hour. Being desirous to obey the request of the said Signoria... they decided that Giovanni, Chief of the Works, and Francesco di Manello, Purveyor of said Opera should send to and install in the aforesaid palace the said marble figure. (*Delib.*, LXX, folio 33v.)

21. (426) 1416, August 27.

To Donato di Niccolò di Betto Bardi, sculptor of statues, for several days that he has spent with one or others of his assistants in adapting and completing the figure of David, which is to be sent by the said Operai to the palace of the Signoria, that is, of 119

dominorum priorum, fl. v au. (*Delib.*, LXX, c. 8.)

A Donato di Nicholò di Betto Bardi, intaglatore di figure, per più opere di se e di suoi lavoranti mise in compiere e acconciare la figura di David che si mandò in palagio per comandamento de' Signori, in tutto f. v d'oro. (*Stanz.*, QQ, c. 127t.)

22. (427) 1416, September 18.

A Fermalpunto, isattore de l'opera, per le infrascritte spese per la figura di David ch' e'Signori voglono in palagio:

A dì 4 d'Agosto per dare a due portatori per portare due beccha-telli di marmo in palagio de' Signori per la detta figura, s. VI.

A dì 17 d'Agosto 1416 a Nanni di Salvi, carradore, per portare la detta figura da l'opera al palagio de' Signori, s. XX.

A dì detto a Nanni di Fruosino maestro detto Testa per pezzi 40 d'oro battuto s. XXVI d. VIII e per ariento battuto s. VI p. e per ½ oncia d'azzurro s. XXX e per cinabro e laccha s. IV e per istuccho s. V per le tarsie di vetro della basa e becchatelli della detta figura e per matto e olio s. X e per 50 pezzi d'oro battuto s. XXXIII p. per adornare la detta figura e per sua faticha l. VII p. e in tutto sono l. XII s. XIV d. VIII p.

A dì 20 d'Agosto 1416 a Giovanni di Guccio, dipintore, per dipignere gigli nel champo azurro nel muro dove è posta la detta figura di David in palagio de' Signori, per tuto l. III s. X p. (*Stanz.*, QQ, c. 125t.)

the Priors of the Guilds, at the request of the said Priors, 5 gold florins. (*Delib.*, LXX, folio 8.)

To Donato di Niccolò di Betto Bardi, sculptor of figures, for additional work done by him and his assistants in completing and setting in order the figure of David which is to be sent to the palace on command of the Signoria, 5 gold florins in all. (*Stanz.*, QQ, folio 127v.)

22. (427) 1416, September 18.

To Fermalpunto, notary of the Opera, concerning the expenses listed below for the figure of David which the Signoria wants in the palace [Palazzo della Signoria]:

On August 4, to pay two porters for carrying two marble brackets to the palace of the Signoria for the said figure, 6 soldi.

On August 17, to the carter Nanni di Salvi, for transporting the said figure from the Opera to the palace of the Signoria, 20 soldi.

On the same day, to Master Nanni di Fruosino, called Testa, for 40 pieces of gold leaf, 26 soldi, 8 denari; and for silver leaf, 6 soldi; and for half an ounce of blue pigment, 30 soldi; and for vermilion and lake, 4 soldi; and for stucco for the inlays of glass on the base and brackets of the said figure, 5 soldi; and for ground brick and oil, 10 soldi; and for 50 pieces of gold leaf to ornament the said figure, 33 soldi; and for his labor, 7 lire; in all, 12 lire, 14 soldi, 8 denari.

On August 20, 1416, to the painter Giovanni di Guccio, for painting lilies on a blue ground on the wall against which the said figure of David is placed in the palace of the Signoria, in all 3 lire, 10 soldi. (*Stanz.*, QQ, folio 125v.)

23. (435) 1426, July 11.

Deliberaverunt quod Batista Antonii, capudmagister, teneatur actari facere figuram terre chotte nomine Jesue que erat versus domum Luce Pieri Rainerii ac etiam actari facere certum musay-cum fractum in facie maioris ecclesie coram oratorio s. Johannis Batiste. (*Delib.*, 1425–1436, c. 36t.)

24. (436) 1426, July 30.

Ispese fatte per achonciare e inbianchare el gioghante ch'ène dallato de' lingniaiuoli per più spese fatte chome è suto di bisog-nio, chome apare qui a piè cioè a dì 30 di Luglio: a Nicholò orpellaio stane in Chamaldoli, per lb. 24 d'olio di lino seme l. iii s. iv; allo speziale dell' asengnia della vergine Maria per lb. 20 di biacha l. iii s. viii d. iv; a Nanni di Fruosino per tre pennegli s. xii; asSimone stovigliaio per 4 pentole invetriate s. iv d. iv; a Bonifazio speziale per lb. di vernice a verderame l. i, s. ix, d. iv. (*Stanz.*, BB, c. 20t.)

25. (437) 1463, April 16.

Locaverunt Aghostino Antonii Gucci de Florentia unum gigan-tem prout particulariter adparet in libro locationum. (*Delib.*, 1462–1472, c. 1.)

Prefati operai allogharono a Aghostino d'Antonio di Ducc(i)o di Firenze, scoltore, uno gughante in quella forma e manera che quello el quale è sopra alla porta che va a'Servi o migliore et questo fecono per pregio di l. cccxxi fp; e detto maestro Aghostino

23. (435) 1426, July 11.

It was decided that Battista d'Antonio, Chief of the Works, should be ordered to have repairs made on the figure of terra cotta named Joshua, which faces the house of Luca di Piero Ranieri, and also to order repairs for a certain mosaic on the façade of the Duomo, facing the church of S. Giovanni Battista. (*Delib.*, 1425–1426, folio 36v.)

24. (436) 1426, July 30.

Herewith are recorded expenses made in whitening and repairing the giant which faces the linenweavers' quarter [?], as well as additional expenses as they became necessary, up to this day in July, as follows:

To Niccolò, a gold-beater [?] resident in the Camaldolensian monastery, for 24 pounds of linseed oil, 3 lire, 4 soldi.

To the apothecary at the sign of the Virgin Mary, for 20 pounds of whiting, 3 lire, 8 soldi, 4 denari.

To Nanni di Fruosino for three brushes, 12 soldi.

To the potter Simone for 4 glazed jars, 4 soldi, 8 denari.

To the apothecary Bonifazio for...pounds of *vernice* [with] verdigris, 1 lira, 9 soldi, 4 denari. (*Stanz.*, BB, folio 20v.)

25. (437) 1463, April 16.

They [the Operai] commissioned from Agostino d'Antonio di Duccio of Florence a giant as it is recorded in greater detail in the book of contracts. (*Delib.*, 1462–1472, folio 1.)

The aforesaid Operai commission from the sculptor Agostino d'Antonio di Duccio of Florence a giant in that shape and style as that which is above the door leading to the church of the Servites, or better, and this is to be made for the price of 321 lire.

promisse dare fatto detto ghughante per tutto el mese d'Aghosto sotto la pena dello albitrio di detti operai e chonducello a ongni sue spese a piè dove s'anno a porre chon ongni sue spese et pro eo oblighò se e sua rede et boni, presenti ser Anbruogio d'Angnolo Angeni et Giovanni di Francesco Zati. (*Bast. di ser Niccolò di Diedi* segn. i, c. 1t–2.)

In Dei nomine, amen. Anno domini ab eius salutifera incarnatione millesimoquatrigentesimo sexagesimo terzo (*!*), inditione 11, die 16 mensis Aprelis. — Nobili homini Domenicho di Giovanni G(*i*)ungni et Ruggieri di Thommaso Minerbetti, operai dell' opera di sancta Maria del Fiore di Firenze, insieme raghunati nel lu(*o*)gho della loro solita residentia per loro ufic(*i*)o esercitare come è usanza, servate tutte le cose da observare, meso fatto et celebrato tra lloro solenne e segreto squiptineo a fave nere et bianche et optenuto il partito secondo la forma et hordini di detta opera, deliberorono et alloghorono a (*A*)ghostino d'Antonio di Ducc(*i*)o di Firenze, scultore, in suo nome proprio a fare uno gughante overo Erchole per porre in sullo edifitio et chiesa di sancta Maria del Fiore di quella grandezza et altezza et che chorisponda a quello che è sopra alla porta di detta chiesa che va a Servi et in forma et maniera di profeta. Et questo fec(*i*)ono per pregio et nome di pregio di fiorini cccxxi; e detto Aghostino promesse dare fatto detto gughante per tutto el mese d'Aghosto 1463, sotto la pena dello albitio (*!*) di detti operai; et però oblighò a me Bartholomeo notaio di detta opera et ricevente per essa se et sua rede et boni presenti et futuri. (*Allog.,* c. 78t.)

And the said Master Agostino promises to give over to the making of said giant his time up to and including the month of August, under the penalty of a fine from the said Operai. And they will take charge of all expenses that he will have to incur, provided that these are necessary, and attested to by his own word and his own goods as security. Witnessed by Ser Ambrogio d'Agnolo Angeni and Giovanni di Francesco Zati. (*Bast. di Ser Niccolo di Diedi* series i, folio 1v–2.)

In the name of God, amen. In the year of Our Lord and from His incarnation for our salvation 1473 [sic], on the 16th of April, at the 11th hour. Their worships Domenico di Giovanni Giungni and Ruggieri di Tommaso Minerbetti, Operai of the Opera of S. Maria del Fiore of Florence, having come together in the place of their usual meeting to perform their office as is customary, and having observed all the required ceremonies, that is, having a mass celebrated and sung after their solemn and secret voting by means of black and white beans, and having held the voting according to the forms and ordinances of the said Opera, do hereby decide to commission from the sculptor Agostino d'Antonio di Duccio of Florence, here acting in his own behalf, a giant, that is, a Hercules to be put on the building and church of S. Maria del Fiore, and to be of the same height and size which will correspond to that which is above the door of the said church which leads toward the Servites [SS. Annunziata] and in the form of a prophet. They award this for a fee in the sum of 321 florins [lire]. The said Agostino promises to have the said giant made by the end of August 1463, under penalty of a fine from the said Operai. And I, Bartolomeo, notary of the said Opera, am obliged to receive as security himself, his word, and his goods both present and future. (*Allog.*, folio 78v.)

26. (438) 1463, April 19.

Anchora deliberororo che, intexo l'aloghagione fatta a maestro Aghostino del ghugante chome apare in questo a c. 2., ched e' si facci in quel titolo overo titolato in quel modo dirà messer Antonio da Cercina. (*Bast.*, I, c. 3.— *L'Antonio da Cercina qui ricordato è Antonio di ser Matteo Piccini, cerimoniere*)

27. (439) 1463, April 19.

A Aghostino d'Antonio dughuccio (*!*) per parte del gughante fà in sulla chiesa di santa Maria del Fiore, l. LV s....(*Bast.*, I, c. 2t.)

28. (440) 1463, November 23.

Prefati operarii, intexo una alloghagione fatta a Aghostino di Ducc(*i*)o d'uno gunghante piu tempo fa (*in margine*: ciòe sotto dì 16 d'Aprile 1463) et intexo detto ghughante esser fatto nella perfetione chome gli fu alloghato, per relatione di Bernardo di Matteo chapo maestro et altri, quello accettoro per ben fatto et in perfetione. Item stantioro ongni suo resto restasse avere dall' opera che sono l. CCLXV, s. XIII p. (*Bast.*, segn. I, c. 32t.)

29. (441) 1464, August 18.

Nobiles et prudentes viri Andreas Johannis della Stufa et Jacopus Ugholini de Mazzinghis, operarii opere s. Marie del Fiore de Florentia, locaverunt Aghostino Antonii Ghucci, scultori, cittadino fiorentino, una fighura di marmo bianco chavata a Charrara di bracc(*i*)a nove a ghuisa di gughante e in vece et nome

26. (438) 1463, April 19.

Concerning the commission awarded to Master Agostino for the giant as recorded on folio 2 of this work, it was decided in addition that it would be made in that form, or rather that abbreviated form, in that manner which Master Antonio da Cercina would specify. (*Bast.*, I, folio 3.) — The Antonio da Cercina here mentioned is Antonio di Ser Matteo Piccini, master of ceremonies.

27. (439) 1463, April 19.

To Agostino d'Antonio di Duccio for partial payment on the giant that he is making for the church of S. Maria del Fiore, 55 lire ... (*Bast.*, I, folio 2v.)

28. (440) 1463, November 23.

The aforesaid Operai, having understood that a contract was made some time ago (in the margin: that is, under April 16, 1463) with Agostino di Duccio for a giant, and having learned from the testimony of Bernardo di Matteo [Bernardo Rossellino] Chief of the Works, and others, that the giant has been made and completed as the contract specified, now do accept this figure as well made and complete. Item: they will pay all the rest of his expenses that remain unpaid from the work, namely 265 lire, 13 soldi. (*Bast.*, series I, folio 32v.)

29. (441) 1464, August 18.

The trusted and honorable Andrea di Giovanni della Stufa and Jacopo di Ugolino dei Mazzinghi, Operai of the Opera of S. Maria del Fiore of Florence, commission from the sculptor Agostino d'Antonio di Duccio, citizen of Florence, a figure of marble to be quarried at Carrara, nine *braccia* in height, at the scale of a giant,

...profeta per porre in sununo degli sproni di s. Maria del Fiore d'atorno alla tribuna di detta chiesa dove parrà agli operai che pe' tenpi saranno, la quale fighura promette fare di pezzi quattro cioè un pezzo il chapo ella ghola 2 pezzi le braccia e resto in pezzi uno: la quale debbe fare in modo e in perfetione che risponda al modello fatto per detto Aghostino di cera, el quale ène nell' udienza di detti operai quanto all' aparenza, ma sia di detta misura di br. nove chorrispondendo meglio se meglio può essere: della quale debbe avere, fornita conpiuta e in perfetione facta et condotta a piè di detto sprone a ongni sua spesa, f. ccc di suggello de' quali fior. ccc. ne debba avere a presente f. lxv per andare a Charara abozzare detta fighura. El quale Aghostino fu d'acordo chon detti operai mettere tanti pengni nell' opera che stessino per sicurttà di detti f. lxv e che fussi per valuta di f. lxxx o meglio, e condotta l'arà in Pisa, se gli bisongnasse, se gli presti danari secondo che parrà agli operai che pe' tenpi saranno e così da Pisa a Singna e da Singna a Firenze, se gli bisognasse, l'opera paghi dette spese et ponghansi in conto di detti fior. ccc, cioè a suo conto, et di poi dì per dì paghare detto Aghostino secondo lavorerà et secondo parrà a detti operai che pe' tenpi saranno, agravando le loro chosciienze; nientedimeno non si gli possa paghare tanti danari che, finita detta fighura et posta a piè di detto sprone, non resti avere f. L per lo meno; la quale fighura debba avere facta et compiuta et posta a piè di detto sprone per tenpo et termine di mesi dic(i)otto incominciati a di 1º di Septenbre 1464 et finiti come segue e, dipoi sarà compiuta chome di sopra, per gli operai che pe' tenpi saranno si deba fare stimare detta fighura per persone intendenti di ciò et stimata l'aranno, se fussi stimata meno che detti f. ccc, debba avere quel meno et, se

and in the appearance and name of...a prophet, to be placed
up on one of the buttresses of S. Maria del Fiore next to the
Tribuna of the said church, where it may please the Operai who
will be in office in the future. The figure is to be made from four
blocks: namely, one piece for the head and neck; two pieces for
the arms; and one piece for the rest. The said figure is to be made
in the manner and appearance corresponding to the wax model
made by the said Agostino, which is in the audience hall of the
said Opera, as far as its appearance is concerned; but it should be
of the said height of nine *braccia*, with each part corresponding
to scale as best as possible. When the work is furnished complete,
and made to perfection, and brought to the foot of said buttress,
he should have for all his expenses 300 florins *di suggello*; of
which 300 florins, he should have 65 florins immediately to go to
Carrara to block out the figure. This same Agostino has agreed
with the said Operai to give such pledges to the Opera that would
be security for the said 65 florins, and which would be to the value
of 80 florins, or better. If the figure is conveyed from Carrara to
Pisa, and if funds are needed, moneys will be loaned as may
please the Operai in office at that time; and similarly from Pisa to
Signa, and from Signa to Florence, if funds are required; the
Operai will pay said expenses, putting them on the account of
300 florins, that is, his account. And from time to time they will
pay the said Agostino, according to how he works, and according
to how the work will appear to the Operai in office at that time,
as it may please their judgment. Nevertheless, they are not to pay
out so much money that there will be less than 50 florins remain-
ing in the account when the said figure is finished and placed at
the foot of said buttress. The said figure is to be made and com- 129

fussi stimata più, debba avere f. ccc et non più et ingnuno modo passare detta somma di f. ccc. Alle quali tutte cose detto maestro Aghostino fu presente et consentiente et così rimase d'acordo chon detti operai: la quale alloghagione letta examinata et detto Aghostino a quella ratifichò e accettò presenti Giovanni di Francesco Zati et ser Anbrogio di Angno (*lo*) Angeni e Matteo di Tano lingnaiolo. (*Bast.* segn. I, c. 75t–76t.)

30. (442) 1464, August 18.

Aghostino d'Antonio di Ghuccio, scultore, f. xix. (*Bast.* segn. I, c. 75.)

31. (443) 1465, April 18.

Aghostino Antonii Ghuccii f. vi s. v s. xiv d. vi p. per parte d'una fighura fa per l'opera. (*Bast.* segn. I, c. 103.)

32. (444) 1466, December 20.

Prefati operarii simul congreghati in loco eorum solite residentie, servatis servandis, intelecto qualiter per operarios preteritos fuit locatum Aghostino Antonii Ghuccii, scultori, et fuit de anno 1463 (*!*) et mense Aghusti, unum gighans illis pactis et modis prout in dicta locatione continetur, capite lecto quod dictum

pleted and brought to the foot of the said buttress within a period and time-limit of eighteen months, beginning on September 1, 1464. And when this will occur, and if it is completed as specified above, and if the Operai then in office want to have it evaluated by persons competent to judge such things, and when it is evaluated, let it be at less than the said 300 florins, since it should be worth less than that; and if it is valued at more, let him have 300 florins and no more; and in no case should the said sum of 300 florins be increased. The said Master Agostino has witnessed and agreed to all these conditions, and is therefore in agreement with the Operai. This contract has been examined carefully, and the said Agostino has ratified this, and it has been accepted by those present Giovanni di Francesco Zati, and Ser Ambrogio d'Agnolo Angeni, and Matteo di Tano, woodworker. (*Bast.*, series I, folio 75v.–76v.)

30. (442) 1464, August 18.

To the sculptor Agostino d'Antonio di Duccio, 19 florins. (*Bast.*, series I, folio 75.)

31. (443) 1465, April 18.

To Agostino d'Antonio di Duccio, for partial payment on a figure that he is making for the Opera, 6 florins, 5 lire, 14 soldi, 6 denari. (*Bast.*, series I, folio 103.)

32. (444) 1466, December 20.

The aforesaid Operai, having gathered together in the place of their accustomed meetings, and having received reports, do hereby take notice that the previous Operai had made a contract with the sculptor Agostino d'Antonio di Duccio, in the month of August, 1463 [sic], for a giant under those conditions and terms as

131

gighans et fighura fuit locatum dicto Aghostino in quatuor petiis videlicet unum petium caput et unum petium totum (?) corpus et rexidua brachia et pedes; capite lecto quod dictus Aghostinus fecit dictam fighuram marmoream unius petii cum mangno spe(*n*)dio et expensa et intelletto quod pro labore et maesterio dicte fighure habere debebat fl. ccc larghos illis pactis et modis prout in dicta locatione continetur, et intelecto quod dicta fighura pro faciendo unius petii est maxime valute et pretii quam quatuor petiorum, et intelecto quod dictus Aghostinus in sua utilitate propia nichil habuit pro labore et magisterio quod habet in dicta fighura, et intelecto quod dicta fighura fuit locata dicto Aghostino pro fl. ccc auri pro faciendo predictam quatuor petiorum, et inteletto quod dicta fighura est maximi magisterii (!) unius petii quam quattuor, et intelecto quod dicta fighura per dictum magistrum Aghostinum fuit locata Bacellino de Septingnano ed quod dictus Bacellinus nichil habuit pro suo labore, quia dictus Aghostinus lochavit dicto Bacellino dictam fighuram donducere a cava marmoris usque ad operam pro fl. c de dictis quatuor petiis et postea conduxit dictam fighuram et lapidem unius petii per supradictum pretium... deliberaverunt quod, pro omni et toto eo quod dictus magister Aghostinus habuit et habere potest, habeat l. ccxliiii et, facta dicta solutione, numquam posset petere aliquid a dicta opera pro suo labore dicte fighure et dicta fighura sit et remaneat in manibus dictorum operariorum et de ea possint facere eorum velle. (*Delib.*, 1462–1472, c. 44–44t.)

contained in the said contract. Firstly, they note that it was agreed by the said Agostino that the said giant and figure would be in four pieces, namely, one piece for the head, and one piece for all the body, and the rest for arms and legs [sic]. Next, they note that the said Agostino has made the said figure from one block of marble, at great cost and expense. They note that he should have had 300 florins for the labor and craftsmanship of the said figure according to the conditions agreed upon, as the terms are specified in the said contract. They note that making the said figure from one block rather than four involves greater cost and value. They note that the said Agostino has had nothing for his own services as compensation for his labor and work, which he should have had for the said figure. And they note that the said Agostino was awarded the said figure for the sum of 300 gold [sic] florins specifically for making it of four pieces; they note that the said figure requires greater craftsmanship when of one piece rather than four. Furthermore, they note that the said Master Agostino contracted with Bacellino da Settignano for the said figure, and that the said Bacellino has had nothing for his labor; to wit, that said Agostino commissioned said Bacellino to transport the said marble figure from the marble quarry to the Opera for 100 florins for the said four pieces, and afterwards he brought the said figure and block of one piece for the aforesaid price... They decided that Master Agostino should have 244 florins for all and everything that he has had and ought to have, and, when this payment is made, he can no longer ask anything from the said Opera for the said figure. The said figure will remain and stay in the hands of the said Operai, and they can do with it what they wish. (*Delib.*, 1462–1472, folio 44–44v.)

133

33. (445) 1466, December 30.

Prefati operarii, intelecta quadam deliberatione facta in favorem magistri Aghostini intagliatoris ... deliberaverunt quod provixor dicte opere ponat in creditorem magistrum Aghostinum predictum fl. CVII (*prima era scritto:* quinquaginta septem) et lb. MCCCII s. VII et d. II et ponat per debitorem unam fighuram marmoream ... existentem in opera videlicet apud ecclesiam. (*Delib.*, 1462–1472, c. 45t.)

34. (446) 1476, May 6.

Operarii alluoghano Antonio di Matteo Ghanberelli, scultore e scarpellatore, considerato che g(i)à sono molti anni che fu alloghato Aghostino scultore uno gughante di marmo el quale è al presente allato a' fondamenti el quale gughante s'aveva a finire e porre in sununo degli sproni della chiesa. (*Lacuna: Delib.*, 1472–1476, c. 48.)

35. (447) 1477, January 1.

Una statua di marmo fatta venire dacCharrara più tempo fa per fare 1⁰ giughante per uno dé pinacholi della chupola dé dare addì primo di Giennaio 1476/77, chome appare allibro s. O in quello c. 146, f. CXXX l. MCCCVI s. — d. VI. (*Entrate e spese*, 1477, c. 172.)

36. (448) 1501, July 2.

Operarii deliberaverunt quod quidam homo ex marmore vocato Davit male abbozatum et sculptum existentem in curte dicte opere et desiderantes tam dicti consules quam operarii talem gigantem erigi et elevari in altum per magistros dicte opere et in pedes stare ad hoc ut videatur per magistros in hoc expertos possit

33. (445) 1466, December 30.

The aforesaid Operai, noting a certain decision made in favor of the sculptor Master Agostino ... decided that the Purveyor of the said Operai should put to the credit of Master Agostino the aforesaid 107 florins (written first: 57), and 1,302 lire, 7 soldi and 2 denari, and should place in balance a figure of marble ... at present in the workshop by the church. (*Delib.*, 1462–1472, folio 45v.)

34. (446) 1476, May 6.

The Operai, considering that several years ago the sculptor Agostino was commissioned to make a marble giant which is at present in the corner by the cellars [Opera storage area], do commission Antonio di Matteo Gambarelli [Antonio Rossellino], stonemason and sculptor, to finish the giant and to have it placed on one of the buttresses of the church. (Lacuna: *Delib.*, 1472–1476, folio 48.)

35. (447) 1477, January 1.

A marble statue [sic] which was brought from Carrara several years ago for making one giant for one of the buttresses of the dome is to be awarded on this day, January 1, 1476/77, as it appears in the book, series O, folio 146, for 130 florins, 1,306 soldi, and 6 denari. (*Entrate e spese*, 1477, folio 172.)

36. (448) 1501, July 2.

The Operai noted that there is a certain figure of marble named David, badly blocked out and carved, at present in the courtyard of the said Opera. Since the aforesaid consuls as well as the Operai want such a giant to be made and put up on high by the masters of the said Opera, and to be put upright, in its proper place, they

135

absolvi et finiri. (*Delib.*, 1498–1507, c. 36t.)

37. (449) 1501, August 16.

Spectabiles viri consules artis lane una cum dominis operariis adunati in audientia dicte opere, attendentes ad utilitatem et honorem dicte opere, elegerunt in sculptorem dicte opere dignum magistrum Michelangelum Lodovici Bonarroti, civem florenti-num, ad faciendum et perficiendum et pro fede finiendum quendam hominem vocato Gigante abozatum, brachiorum 9 ex marmore, existentem in dicta opera, olim abozatum per magi-strum Augustinum grande (?) de Florentia, et male abozatum, pro tempore et terminoannorum duorum proxime futurorum, incipi-endorum kalendis Settembris proxime futuri et cum salario et mercede quolibet mense fl. vi au. latorum de moneta; et quicquid opus esset eidem circa dictum edificium faciendum, opera teneatur eidem prestare et commodare et homines dicte opere et lignamina et omnia quecumque alia quibus indigeret; et finito dicto opere et dicto homine marmoreo, tunc consules et operarii qui tunc erunt, iudicabunt an mereatur maius pretium; remic-tentes hoc eorum conscientiis (*in margine:* Incepit dictus Michel-angelus laborare et sculpere dictum gigantem die 13 settembris 1501 et die lune de mane, quamquam prius videlicet die 9 eiusdem uno vel duobus ictibus scarpelli substulisset quoddam nodum quem (!) habebat in pectore: sed dicto die incepit firmiter et fortiter laborare, dicto die 13 et die lune summo mane. (*Delib.,* 1498–1507, c. 186.)

decided that masters competent in these affairs should investigate to determine if this matter could be completed and brought to an end. (*Delib.*, 1498–1507, folio 36v.)

37. (449) 1501, August 16.

Their excellencies the consuls of the Arte della Lana meeting together with the Operai in the audience hall of the Opera, and being mindful of the usefulness and honor of the said Opera, do appoint as sculptor of the said Opera the worthy master Michelangelo di Lodovico Buonarroti, a citizen of Florence, to the end of making and completing, and, in good faith, finishing a certain marble figure called the Giant, blocked out in marble nine *braccia* high, now in the cathedral workshop, and formerly blocked out by Master Agostino *grande* [?] of Florence, and badly blocked out. The work is to be completed within the time limit of the next two years in the future, beginning with the kalends of September next, with hire and salary at a rate of six broad gold florins per month; whatever work done is to be carried out on the premises of the said building, and the Opera is to assist him with shelter and accommodation, with workmen of the said Opera, and wood, and all that he should need. When the said work and the said marble figure are completed, then the consuls and Operai then in office will judge as to whether the work deserves a better price; this is a matter for their own judgment.

In the margin: The said Michelangelo began to work and carve the said giant on September 13, 1501, a Monday; although previously, on the 9th, he had given it one or two blows with his hammer, to strike off a certain *nodum* that it had in its breast. But on the said day, that is the 13th, a Monday, he began to work with determination and strength. (*Delib.*, 1498–1507, folio 186.) 137

Appendix II-B
Discussion of the placement of the David of 1501–04

T HE following record of a public hearing held on January 25, 1503/04, is from Giovanni Gaye, *Carteggio inedito d'artisti dei secoli XIV, XV, XVI* (Florence, 1840), II, pp. 455–462; originally from Archivio dell'Opera del Duomo, *Deliberazioni*, 1496–1507. The annotated English translation is by Paul Watson. It has been collated with Robert Klein's and Henri Zerner's translation in *Documents on Italian Art, 1500–1600*, ed. H. W. Janson (New York, 1966), pp. 39–44. The translation given here is literal; it makes no attempt to render the nuances of personal and local accent in the speeches of the various participants.

Il Davidde di Michelagniolo

MDIII. Die 25 mensis Ianuarii

Viso qualiter statua seu David est quasi finita, et desiderantes eam locare et eidem dare locum conmodum et congruum, et tale (*sic*) locum tempore, quo debet micti et mictenda est in tali loco, esse debere locum solidum et resolidatum ex relatu Michelangeli, magistri dicti gigantis, et consulum artis lane, et desiderantes tale consilium mitti ad effectum et modum predictum etc., deliberaverunt convocari et coadunari ad hoc eligendum magistros, homines et architectores, quorum nomina sunt vulgariter notata, et eorum dicta adnotari de verbo ad verbum:

 Andrea della Robbia
 Giovanni Cornuola
 Vante miniatore
 Laraldo di palazzo
 Giovanni piffero
 Francesco d'Andrea Granacci
 Biagio pittore
 Piero di Cosimo pittore
 Guasparre orafo
 Ludovico orafo e maestro di gietti
 El Riccio orafo
 Gallieno richiamatore

140

1503/04, January 25.

Considering that the statue of David is almost finished, and desiring to install it and to give it an appropriate and acceptable location, with the installation at a suitable time, and since the installation must be solid and structurally trustworthy according to the instructions of Michelangelo, master of the said Giant, and of the consuls of the Arte della Lana, and desiring such advice as may be useful for choosing the aforesaid suitable and sound installation, etc., they decided to call together and assemble, to decide on this, competent masters, citizens, and architects, whose names are listed below in the normal style, and to record their opinions, word for word.

Andrea della Robbia[1]
Giovanni Cornuola[2]
Attavante, miniature painter[3]
Francesco, First Herald of the Signoria[4]
Giovanni Cellini, fife-player[5]
Francesco d'Andrea Granacci[6]
Biagio d'Antonio Tucci, painter[7]
Piero di Cosimo, painter[8]
Guasparre di Simone, goldsmith
Ludovico, goldsmith and master of bronze-casting
Andrea, called il Riccio, goldsmith[9]
Gallieno, master-embroiderer

Note: References are on pp. 156–57.

Davit dipintore
Simone del Pollaiuolo
Philippo di Philippo dipintore
Lorenzo dalla Golpaia
Salvestro gioiellieri
Michelangelo orafo
Cosimo Roselli
Chimenti del Tasso
Sandro di Botticello pittore
Giovanni alias vero Giuliano
et Antonio da Sco. Gallo
Andrea da Monte a Sco. Savino
 pittore (*in margine:* e a Genova)
Lionardo da Vinci
Pietro Perugino in pinti pittore
Lorenzo di Credi pittore
Bernardo della Ciecha legnaiuolo

Comparuerunt dicti omnes supra nominati in residentia dicte opere, et tanquam moniti et advocati a duobus operariis ad perhibendum et deponendum eorum dictum etc., et locum dandum ubi et in quo ponenda est dicta statua, et a primo narrando de verbo ad verbum prout retulerunt ex ore proprio vulgariter:

I. *Messer Francesco Araldo della Signoria*
Io ò rivolto per lanimo quello che mi possa dare el iuditio. havete dua luoghi dove può supportare tale statua, el primo dove è la Iuditta, el secondo el mezzo della corte del palazzo, dove è el Davit: primo perchè la Iuditta è segno mortifero, e' non sta

Davide Ghirlandaio, painter[10]
Simone del Pollaiuolo[11]
Filippino Lippi, painter[12]
Lorenzo dalla Golpaia [maker of a famous astronomical clock]
Salvestro, worker in precious stones
Michelangelo Bandinelli, goldsmith[13]
Cosimo Rosselli[14]
Chimenti di Francesco Tassi[15]
Sandro Botticelli, painter[16]
Giuliano da San Gallo[17]
Antonio da San Gallo[18]
Andrea da Monte a San Savino, painter [sic][19] (in the
 margin: at present in Genoa)
Leonardo da Vinci[20]
Pietro Perugino, in Borgo Pinti, painter[21]
Lorenzo di Credi, painter[22]
Bernardo di Marco della Cecca, wood-carver[23]

All of these men listed above appeared in the premises of the
said Opera, and after two of the Operai had admonished and
advised them on the proper presentation and deposition of their
opinions, they gave advice as to where, and in what place, the
said statue was to go; their statements are recorded below ver-
batim in their own words, beginning with the first witness.

1. *Messer Francesco, First Herald of the Signoria*
I have gone over and over in my mind whatever my judgment
offers. There are two places where such a statue might be erected.
The first is where the Judith is,[24] and the second the center of
the courtyard of the Palace, where the David is.[25] The reason for

143

bene, havendo noi la ✠ per insegnia et el giglio, non sta bene che la donna uccida lhomo, et maxime essendo stata posta chon chattiva chonstellatione, perchè da poi in qua siate iti de male in peggio: perdessi poi Pisa. El Davit della corte è una figura et non è perfecta, perchè la gamba sua di drieto è schiocha; per tanto Io consiglierei che si ponesse questa statua in una de' dua luoghi, ma più tosto dove è la Iuditta.

II. *Francesco Monciatto legnaiuolo*

rispose e dixe: Io credo che tutte le cose che si fanno, si fanno per qualche fine, et così credo, perchè fu facta per mettere in su e pilastri di fuori o sproni intorno alla chiesa: la causa di non vele (*sic*) mettere, non so, et quivi a me pareva stessi bene in ornamento della chiesa et de'consoli, et mutato loco. Io consiglio che stia bene, poichè vi siate levato dal primo obiecto, o in palazzo o intorno alla chiesa: et non bene resoluto referiommi al decto daltri, come quello che non ò bene pensato per la extremità del tempo del luogo più congruo.

III. *Cosimo Roselli*

Et per Messer Francesco et per Francesco sè detto bene, che credo che stia bene intorno a quello palazzo. Et avevo pensato di metterlo dalle schalee della chiesa dalla mano ritta, chon uno basamento in sul chanto detto di decte schalee, chon uno inbasa-

the first is because the Judith is an emblem of death, and it is not fitting for the Republic—especially when our emblems are the cross and the lily—and I say it is not fitting that the woman should kill the man. And even more important, it [the group] was erected under an evil star, for from that day to this, things have gone from bad to worse: for then we lost Pisa.[26] The David of the courtyard is a figure that is not perfect, because the leg that is thrust backwards is faulty. For these reasons I would advise putting this statue in one of the two places [indicated] but with my preference for where the Judith now is.

2. *Francesco Monciatto, wood-carver,*[27]

answered and said: I believe that all things that are made are made for a definite purpose. And I believe this because it was made to be placed on the pilasters outside [sic] the church, or else on the buttresses around it [sic]. I don't know your reasons for not wanting to put it there, especially since I feel that it would be an ornament to the church, and to the consuls; but now the location has been changed. Seeing that it will be taken away from the place first intended, I think it would be for the best either in the palace, or outside the church. But my mind is not really made up, and I should listen to what the others say, because I have not really thought about the most suitable place for a long enough time.

3. *Cosimo Rosselli*

Both Messer Francesco and Francesco have spoken so well that I too believe that inside the palace would be a good place. However, I had been thinking of putting it on the steps of the Cathedral, on the right-hand side, and on a pedestal at the corner

mento et ornamento alto, et quivi la metterei secondo me.

IV. *Sandro Botticello*

Cosimo à detto apunto dove a me pare per esser veduto da'viandanti et dall'altro canto con una iuditta, o inella loggia de'Signori, ma più tosto in sul chanto della chiesa; et quivi iudico stia bene et essere el miglior luogo dalorini.

V. *Giuliano Da Sangallo*

Lanimo mio era molto in sul chanto della chiesa, dove à detto Chosimo, et è veduta da'viandanti: ma poi che è cosa pubblica, veduta la imperfectione del marmo per essere tenero et chotto, et essendo stato allaria, non mi pare fussi durabile: per tanto per questa causa ò pensato che stia bene nell'arco di mezo della loggia de'Signori, o inel mezzo dell'arco che si potessi andarle intorno, o dallato drento presso al muro nel mezo, chon un nichio nero di drieto in modo di cappelluza, che se la mettono all'aria, verrà mancho presto, et vuole stare coperta.

VI. *El sichondo Araldo* (*in margine:* el nipote di mess. Francesco, primo dicitore)

Vegho el detto di tutti, et tutti a buono senso intendono per varii modi. Et ricerchando e luoghi rispetto a ghiacci e freddi, ò examinato volere stare al coperto, et elluogho suo essere nella loggia detta e nell'archo presso al palazzo, et quivi stare coperta

of those stairs, together with a high, ornamented base. And there is where I think it should go.

4. *Sandro Botticelli*

Cosimo has hit upon the place where I think it can best be seen by passers-by, with a Judith at the other corner. Perhaps also in the Loggia of the Signoria—but preferably at the corner of the Duomo; indeed, I judge it would go well there, for it is the best place of all.

5. *Giuliano da San Gallo*

My judgment too was much inclined in favor of the corner of the Duomo that Cosimo mentioned, where it would be seen by the people. But, consider that this is a public thing, and consider the weakness of the marble, which is delicate and fragile. Then, if it is placed outside and exposed to the weather, I think that it will not endure. For this reason as much as any, I thought that it would be better underneath the central arch of the Loggia of the Signoria: either underneath the center of the vault, so that you can go in and walk around it; or else at the back by the wall, in the middle, with a dark niche behind it as a sort of tabernacle. Remember that if it is put outside, it will soon weather badly. Therefore, it should be under cover.

6. *Angelo, the Second Herald, and a nephew of Messer Francesco* [28]

I have listened carefully to all these opinions, and everyone has put forth good suggestions, for many reasons. Now in thinking of these places with reference to frost and cold weather, I have been mindful of the need for shelter. The site should be inside the Loggia just mentioned, but beneath the arch nearest the palace.

et essere honorata per chonto del palazzo; et se nell'archo di mezo si mettessi, si romperebbe lordine delle ceremonie, che si fanno ivi per e Signori e li altri magistrati, et avanti che si disponghino le magnificentie V. dove à a stare, lo conferiate chon li Signori, perchè vi à di buoni ingiegni.

VII. *Andrea vocato El Riccio Orafo*

Io mi achordo dove dicie Messer Francesco Araldo, et quivi stare bene coperta, et essere qui più stimata et più riguardata quando fussi per essere guasta, et stare meglio al coperto, et e viandanti andare a vedere, et non tal cosa andare incontro a'viandanti, et che noi et e viandanti landiamo a vedere, et non che la figura venghi a vedere noi.

VIII. *Lorenzo Dalla Golpaia*

Io mi achordo al detto dell'Araldo di sopra vocato, del Riccio et di Giuliano da S. Ghallo.

IX. *Biagio dipintore*

Io credo che saviamente sia detto, et Io sono di questo parere, che meglio sia dove à detto Iuliano, mettendola tanto drento non guasti le ceremonie delli ufficii si fanno in nella loggia'; o veramente in su le schalee.

X. *Bernardo di Marcho*

Io mi appicho a Giuliano da S. Gallo, et a me pare buona ragione, et vome chon detto Giuliano per le ragioni dallui dette.

There it would be covered, and ennobled by its proximity to the palace. If you put it immediately underneath the central arch, it will disrupt the order of the ceremonies that the Signoria and the other magistrates conduct there. *In the margin* [this was added later, at the end of the session]: Before your Excellencies decide where it is to go, discuss it with the Signoria, for there are good men of sound judgment in that body.

7. *Andrea, called il Riccio, goldsmith*
I agree with what Messer Francesco the herald [sic] said, because it would be well sheltered there [in the loggia]. Besides, it will win more respect and esteem than if it were spoiled [by the weather]. It is better under cover, because the people would go to see it, rather than having such a thing confronting the people; as if we and passers-by should go to see it, rather than having the figure come to see us.

8. *Lorenzo dalla Golpaia*
I agree with the opinions of the herald who has just spoken, with il Riccio, and with Giuliano da San Gallo.

9. *Biagio d'Antonio Tucci, painter*
I think these opinions are sound. I am of the opinion that the best place is where Giuliano advised, provided it is put far enough back so that it does not spoil the ceremonies held by the officials in the Loggia; or perhaps [it might stand better] on the stairs.

10. *Bernardo di Marco della Cecca*
I side with Giuliano da San Gallo, for it seems sensible, and I am with this Giuliano for the reasons he gave.

XI. *Lionardo di S. Piero da Vinci*

Io confermo che stia nella loggia, dove à detto Giuliano, in su el muricciuolo, dove sappichano le spallere allato al muro, chon ornamento decente et in modo non guasti le ceremonie delli uffici.

XII. *Salvestro*

E sè parlato et preso tutti e luoghi, et che le siano tal cose vedute et dette, credo che quello che là facta sia per darle miglior luogo; et io per me stimo intorno al palazzo star meglio, et che quello che là facta non di mancho, come ho detto, sappia meglio el luogo che nissuno, per laria et modo della figura.

XIII. *Philippo di Philippo*

Io (*sic*) per tutti è stato detto benissimo, et credo che el maestro habia meglio et più lungamente pensato el luogo, et da lui s'intenda, et confermando el detto tutto di chi à parlato, che saviamente si è detto.

XIV. *Gallieno richamatore*

A me secondo mio ingegnio, e veduta la qualità della statua, disegnio stia bene dove è ellione di piazza, chon uno inbasamento in ornamento, el quale luogo a tal statua è conveniente, et ellione mettendo allato alla porta del palazzo in sul chanto del muricciuolo.

XV. *Davit dipintore*

A me pare che Gallieno habia detto el luogo tanto degnio quanto altro luogo, et quello sia el luogo congruo et commodo, et porre ellione altrove dove è detto, o in altro luogo, dove meglio fussi indicato.

11. *Leonardo da Vinci*

I agree that it should be in the Loggia, where Giuliano said, but on the parapet where they hang the tapestries on the side of the wall, and with decency and decorum, and so displayed that it does not spoil the ceremonies of the officials.

12. *Salvestro, worker in precious stones*

Almost all the places have been talked about, and much has been said one way or the other. But I believe that the man who made it did so to be worthy of giving it the best possible location. Though for my part I favor the place outside the palace, yet, as I said, he who made it surely knows better than anyone the place best suited to the appearance and character of the figure.

13. *Filippino Lippi*

Though everyone has argued well, I believe that the master-sculptor would know best, because he has spent much time in thinking of a place where he intended to put it. All the same, I approve of all that has been said, for all have talked sensibly.

14. *Gallieno, embroiderer*

As for me, according to my own views, and in view of the quality of the statue, I think that it would go well where the Marzocco of the piazza is,[29] with a richly decorated pedestal. This place is convenient for such a statue. The Marzocco can be put by the side of the doorway of the palace, on the corner of the parapet.

15. *Davide Ghirlandaio, painter*

It seems to me that Gallieno has pointed out the most worthy place of all, and that would be an acceptable and appropriate location. And the Marzocco could go where he said, or in another place; whatever seems best.

XVI. *Antonio legnaiuolo da S. Gallo*

Se el marmo non fusse tenero, elluogo dellione è buono luogo; ma non credo fusse sopportato, essendo stato quivi lungo tempo; per tanto essendo el marmo tenero, mi pare di darli luogo alla loggia, et se non fusse così in sulla strada, e viandanti durino faticha a verderla insino quivi.

XVII. *Michelagnolo orafo*

Questi savi hano bene detto, et maxime Giuliano da S. Gallo; a me pare che el luogo della loggia sia buono, et se quello non piacesse, nel mezzo della sala del consiglio.

XVIII. *Giovanni Piffero*

Poi che vegho la existimatione vostra, Io confermerei il detto di Giuliano se si vedesse tutta, ma non si vede tutta; ma e's'à pensare alla ragione, all'aria, alla apertura, alla pariete e al tecto, per tanto bisognia andarle intorno, et dall'altro lato potrebbe uno tristo darle chon uno stangone: mi pare sia bene nella corte del Palazzo, dove dixe mess. Francesco Araldo, et sarà grande conforto allo auctore, essendo in tale luogo degnio di tale statua.

XIX. *Giovanni Cornuola*

Io ero volto a metterla dove è el lione, ma non haveo pensato el marmo essere tenero et havere a essere guasto dall'acqua et freddi; per tanto Io iudico che stia bene nella loggia, dove Giuliano da S. Gallo à detto.

16. *Antonio da San Gallo, wood-carver*

If the marble were not delicate, the place where the Marzocco is would be right. But I think that it would not survive being placed outside for many years. Seeing that the marble is delicate, I feel it should go inside the Loggia. Besides, if it is not even exactly on the street, passers-by would take the trouble of going to see it there.

17. *Michelangelo Bandinelli, goldsmith*

All these experts have spoken well, but Giuliano da San Gallo best of all. The Loggia seems like a good place to me. If this is not suitable, then in the Sala del Consiglio [presumably of the Palazzo della Signoria].

18. *Giovanni Cellini, fife-player*

Since I value your opinions, let me say that I would support Giuliano's judgment if it [the statue] could be seen all around; but it cannot be seen thus. We must think of [several factors: the question of] proportion, of climate, [size] of opening [of the arch], of the wall [behind it], and of covering. [If in the Loggia], it would be necessary to go round it there, and, besides, some wretch might damage it with a stave. I myself think that it would go well in the courtyard of the palace, as Messer Francesco the herald advised; furthermore, it would be a great triumph for the artist to have such a statue in a place worthy of it.

19. *Giovanni Cornuola*

I had considered putting it where the Marzocco is, but I had not thought that the marble might be delicate and would be damaged by rain and cold. For these reasons I judge that inside the Loggia is a good place, as Giuliano da San Gallo said.

XX. *Guasparre di Simone*

A me pareva metterla in sulla piazza di S. Giovanni, ma a me pare la loggia più commodo luogo, poi che è tenero.

XXI. *Piero di Cosimo dipintore*

Io confirmo el decto di Giuliano da S. Gallo, et più che sene achordi quello che là facto, che lui sa meglio come vuole stare.

Li altri Signori nominati et richiesti chol detto loro, per più brevità qui non si scripsono. Ma el detto loro fu che si riferirono al detto di quelli di sopra, et a chi uno, et chi a un altro di sopra detti senza discrepanza.

20. *Guasparre di Simone*

I was thinking of putting it in the Piazza of S. Giovanni, [i.e. at the façade of the Duomo] but now the Loggia seems a more suitable place, since the stone is weak.

21. *Piero di Cosimo, painter*

I agree with the opinion of Giuliano da San Gallo. Even more I would approve an opinion in agreement with him who made it, since he knows best where he wants it to be.

The other dignitaries nominated and summoned submitted opinions, but these, being very brief, are not herein recorded. Moreover, their opinions were the same as those cited above; all agreed with one or another of the above opinions, without any [substantial] difference.

REFERENCES

1. Andrea della Robbia, sculptor: born Florence, 1435; died 1525; nephew and pupil of Luca della Robbia.
2. Giovanni Cornuola or delle Corniuole, engraver of hard stones; *c.* 1470–1516.
3. Vante di Gabriello, called Attavante, miniature painter; 1452–1517/ 1525.
4. Francesco Filareti: appointed First Herald 1500; died *c.* 1505.
5. Giovanni Cellini, musician to the Signoria, and father of Benvenuto Cellini: 1451–1527.
6. Francesco d'Andrea Granacci, painter; July 21, 1477–November 3, 1543; pupil of Domenico Ghirlandaio, and Michelangelo's intimate friend.
7. Biagio d'Antonio Tucci, painter; 1446–1515; pupil of Cosimo Rosselli.
8. Piero di Cosimo, painter; 1462–1521; pupil of Cosimo Rosselli.
9. Probably not Andrea Briosco, called il Riccio, goldsmith and sculptor from Padua; 1470–1532. He is not known to have come to Florence.
10. Davide di Tommaso del Ghirlandaio, painter; March 14, 1452–April 15, 1525; assistant to his brother Domenico.
11. Simone del Pollaiuolo, called il Cronaca, architect; October 30, 1457–September 27, 1508.
12. Filippino Lippi, painter; born Prato, 1457; died Florence, April 18, 1504; son of Fra Filippo Lippi, and pupil of Botticelli.
13. Michelangelo di Viviano Bandinelli, goldsmith; 1459–August 13, 1528; father of the sculptor Baccio Bandinelli.
14. Cosimo di Lorenzo Rosselli, painter; 1439–January 1, 1507; pupil of Neri di Bicci, Baldovinetti, and Benozzo Gozzoli.
15. Chimenti di Francesco Tassi, wood-carver; 1430–1516.
16. Sandro Botticelli, painter; 1444–1510; pupil of Fra Filippo Lippi.
17. Giuliano da San Gallo, architect, sculptor, and engineer; 1445–October 20, 1516.

18. Antonio da San Gallo, brother of Giuliano, architect; 1455–December 27, 1534.

19. Andrea da Monte a Santo Savino, called Sansovino, sculptor and architect; *c.* 1460–*c.* 1529; pupil of Antonio Pollaiuolo and Bertoldo di Giovanni.

20. Leonardo da Vinci, painter, sculptor, engineer, and architect; born Vinci, 1452; died Amboise, May 2, 1519; pupil of Verrocchio.

21. Pietro di Cristoforo Vannucci, called Perugino, painter; born Perugia, 1446; died Perugia, 1523: master of Raphael.

22. Lorenzo di Credi, painter; 1454–January 12, 1537; pupil of Verrocchio.

23. Bernardo di Marco, called della Cecca, wood-carver; pupil of Francesco d'Angelo.

24. The herald is referring to the bronze group of Judith and Holofernes by Donatello, which had been removed from the Medici palace in 1495, and installed on the *ringhiera* in front of the Palace of the Signoria.

25. This David is Donatello's bronze of *c.* 1435, rather than Verrocchio's, as sometimes identified. It was removed from the Medici palace in 1495 and placed in the courtyard of the Palace of the Signoria.

26. Pisa broke away from Florentine rule after the expulsion of the Medici in 1494. It was not reconquered until 1509.

27. Francesco di Domenico, called Monciatto, wood-carver, intarsia-worker, and architect. With Cronaca he was architect of the Hall of the Great Council in the Palazzo della Signoria.

28. Angelo di Lorenzo Manfredi da Poppi, nephew of Francesco Filareti; appointed Second Herald in 1500; served as First Herald from 1505 to 1527.

29. The Marzocco is the heraldic lion of the Republic. Donatello's is now in the Bargello. A replica of Donatello's statue now occupies the same site in the Piazza della Signoria, on the *ringhiera*, in front of the Palace of the Signoria.

ILLUSTRATIONS

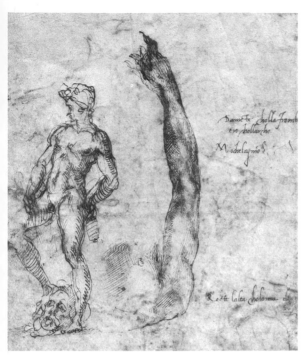

1. Michelangelo. Drawing for bronze David and for arm of marble David, c. 1501-04. Louvre, Paris.

2. Michelangelo. Detail of Figure 1, with scholium and signature: "Davicte cholla fromba/e io chollarcho/Michelagniolo."

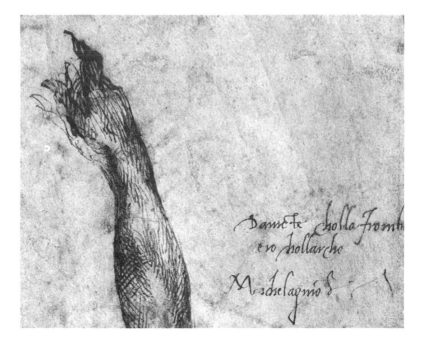

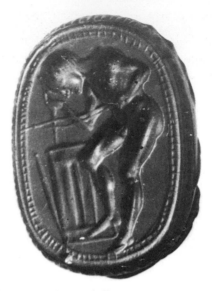

3. Greek use of bow-drill represented on antique cameo. British Museum, London.

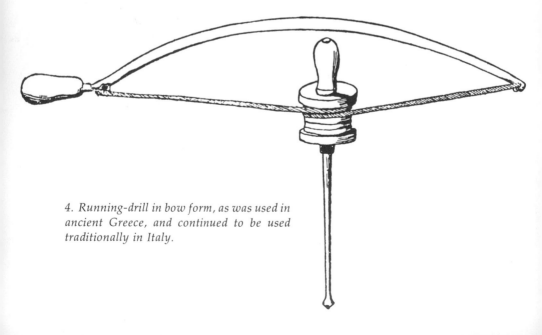

4. Running-drill in bow form, as was used in ancient Greece, and continued to be used traditionally in Italy.

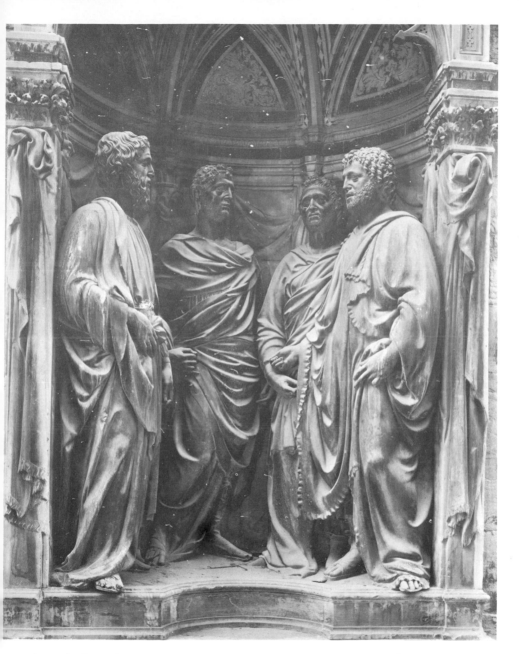

5. Nanni di Banco. Quattro Santi Coronati, c. 1415. Or San Michele, Florence.

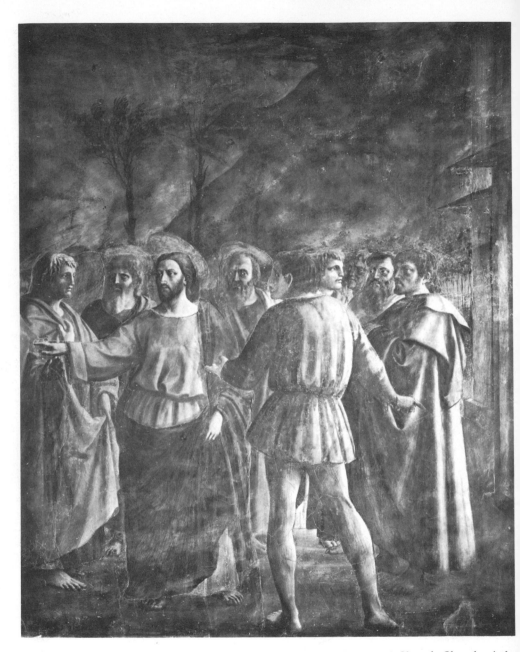

6. Masaccio. Detail of fresco, The Tribute Money, c. 1427. Brancacci Chapel, Church of the Carmine, Florence.

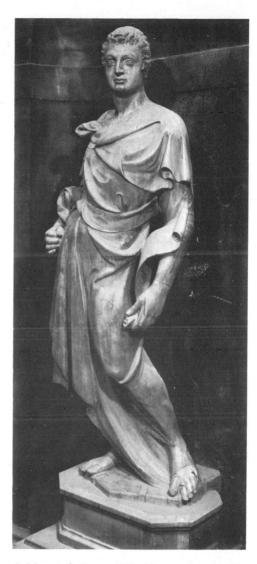

7. Donatello. Marble David, intended originally for summit of buttress on North Tribuna of the Duomo, 1408-09. Partially recut and transferred to the Signoria in 1416. Height: approximately life-size. Now in the Bargello, Florence.

8. Nanni di Banco. Marble prophet Isaiah, intended originally for summit of buttress on North Tribuna of the Duomo, 1408. Height: approximately life-size. Now in the interior of the Duomo, Florence.

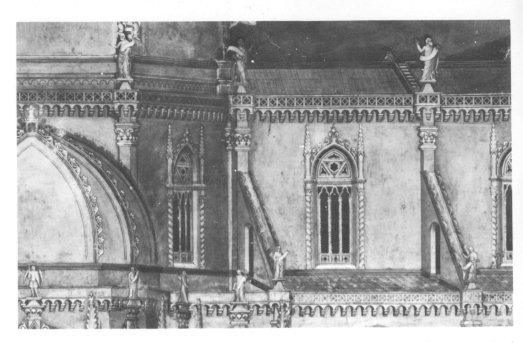

9. *Andrea da Firenze. Detail of model of Duomo with statues of Prophets in place at summit of buttresses, c. 1360. Spanish Chapel, Santa Maria Novella, Florence.*

10. *Pocetti. Detail of fresco, showing Donatello's Joshua in place on North Tribuna of the Duomo, late 16th century. San Marco, Florence.*

11. *Israel Silvestre. Detail of drawing showing Donatello's Joshua in place on North Tribuna of the Duomo, 17th century. Formerly in the collection of Philip Hofer.*

12. *Attributable to Niccolò di Pietro Lamberti. Marble Hercules (Fortitude), c. 1393. Porta della Mandorla, Duomo, Florence.*

13. *Leonardo da Vinci. Vitruvian Man, proportionately established within the square and the circle. Accademia delle Belle Arti, Venice.*

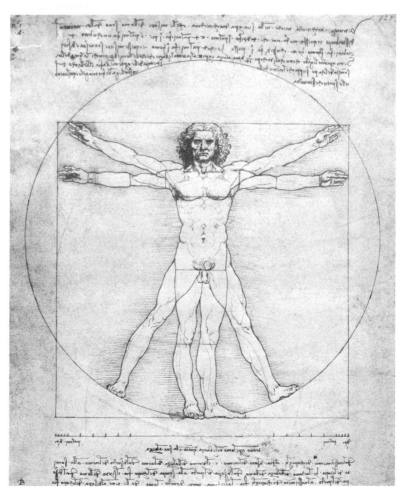

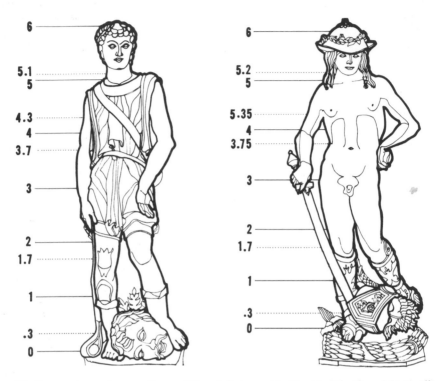

14. *Comparison of proportions of Donatello's marble David of the Casa Martinelli (National Gallery of Art, Widener Collection) and of his bronze David (Bargello). Based on the* exempedum *canon of Leone Battista Alberti which both appear to follow.*

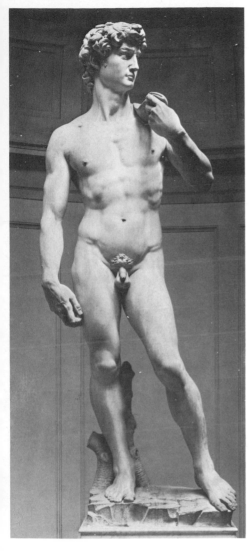

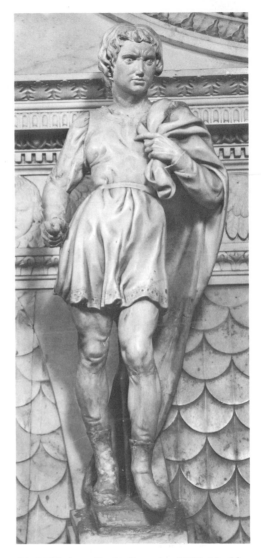

15. Michelangelo. Marble David of 1501-04.
Originally intended for the Tribuna Prophet-
series of the Duomo, but set up near the
entrance of the Palazzo della Signoria in 1504.
Height: c. 9 braccia (c. 17 feet). Now in the
Accademia delle Belle Arti, Florence.

16. Michelangelo. St. Proculus, 1495. Marble,
in several places broken and restored. Height:
27 inches. Shrine of St. Dominic, San Do-
menico, Bologna.

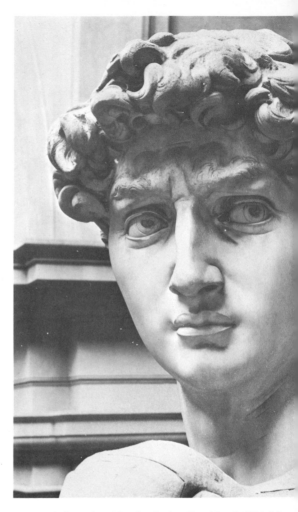

17. Roman Imperial. Head of marble Colossus of Constantine from the Basilica of Maxentius in the Forum Romanum. Now in the Museo dei Conservatori, Rome.

18. Michelangelo. Head of the David of 1501-04. Detail of Figure 15.

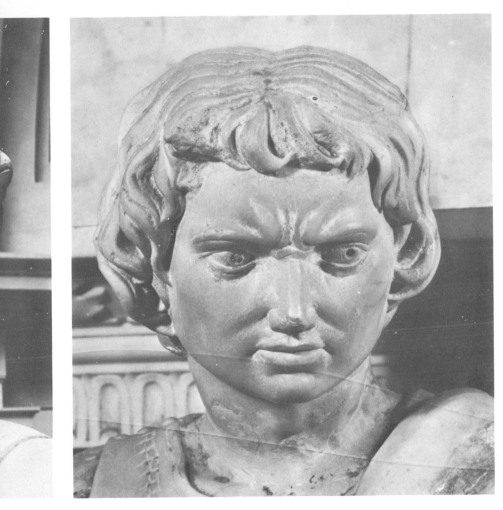

19. Michelangelo. Head of St. Proculus of 1495. Detail of Figure 16.

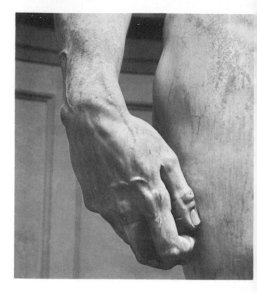

20. *Michelangelo. Right hand of the David of
1501-04. Detail of Figure 15.*

21. *Maerten van Heemskerck. The Colossus
of Rhodes from Pliny's description, c. 1530.
Bibliothèque Royale de Belgique, Brussels.*

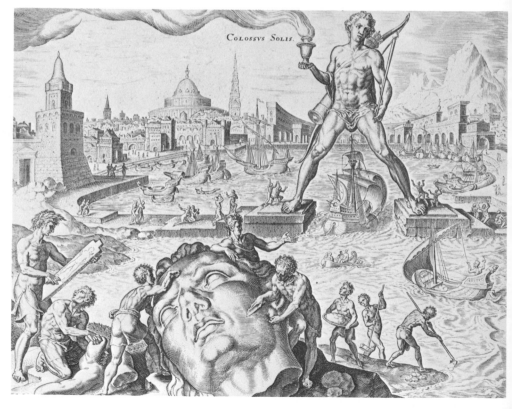

COLOSSVS SOLIS.

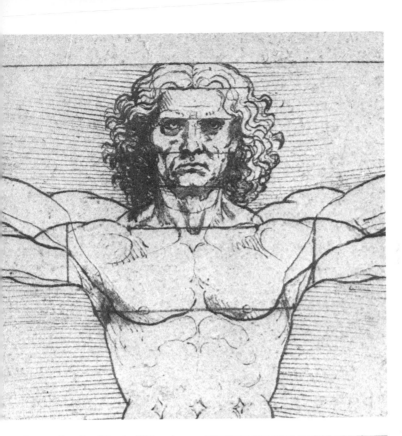

22. Leonardo da Vinci. Vitruvian Man. Detail of Figure 13. Here suggested as an idealized self-portrait.

23. Leonardo da Vinci. Self-portrait, c. 1510. Biblioteca Reale, Turin.

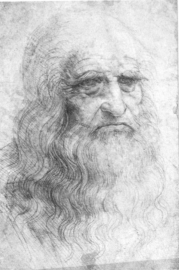

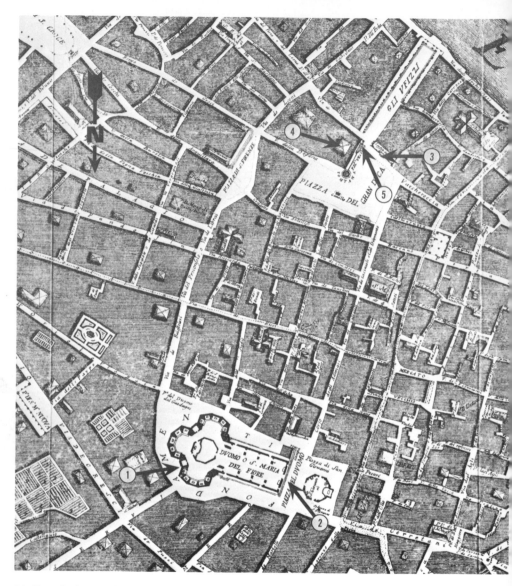

24. *Detail of city-plan of Florence before changes of the 19th century. Arrows have been added to indicate possible emplacement sites for the David: 1 originally intended emplacement on Tribuna buttress (1466-1501); 2 possible alternative emplacement in front of Duomo (as of 1504); 3 Michelangelo's evidently preferred emplacement, Loggia dei Signoria (as of 1504); 4 possible alternative emplacement in court of Palazzo della Signoria (as of 1504); 5 final emplacement choice, on Ringhiera of Palazzo della Signoria (June, 1504).*

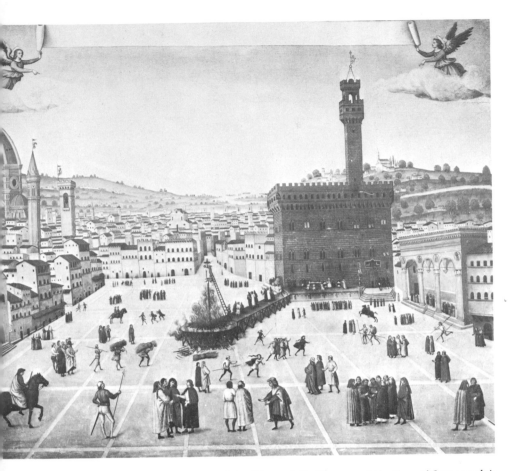

25. *Anonymous Florentine painter. View of the Piazza della Signoria at the time of Savonarola's execution in 1498, with the Loggia at the right,* c. *1500. San Marco, Florence.*

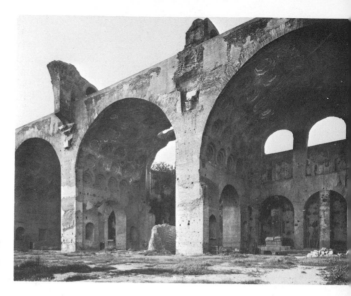

26. *Arches of the Basilica of Maxentius, in the Forum Romanum.*

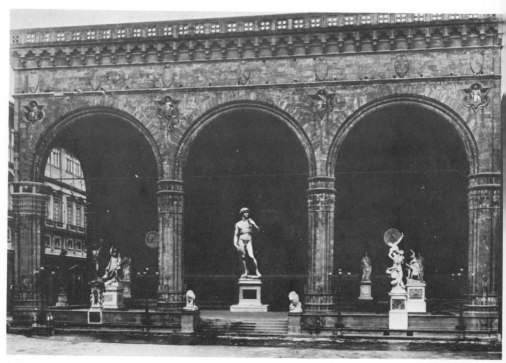

27. *Photomontage showing Loggia dei Signoria with the David of 1501-04 placed to scale under the central arch.*

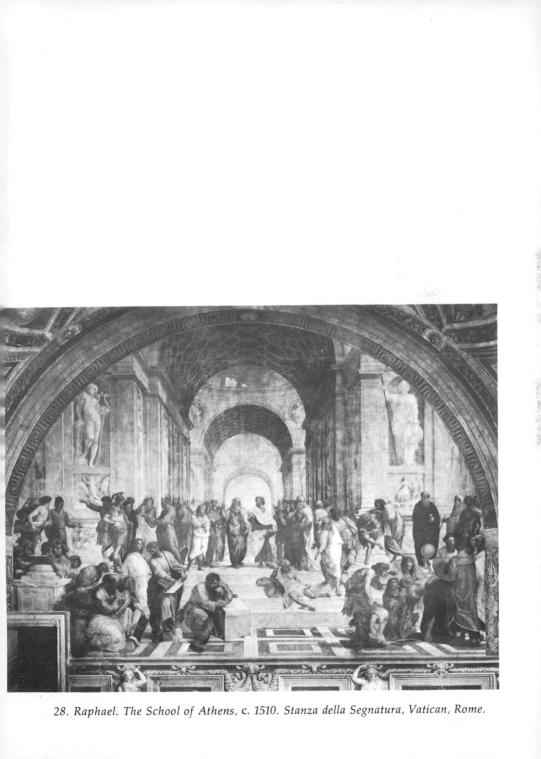

28. *Raphael. The School of Athens, c. 1510. Stanza della Segnatura, Vatican, Rome.*

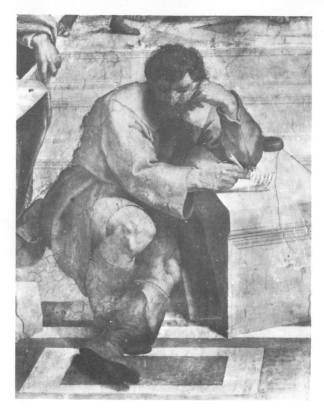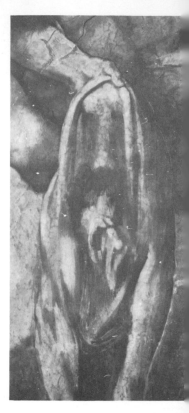

29. *Raphael. Presumed portrait of Michelangelo as a philosopher of melancholy, possibly Democritus. Detail of Figure 28.*

30. *Michelangelo. Ironic self-portrait in The Last Judgment, Sistine Chapel, 1534-43.*

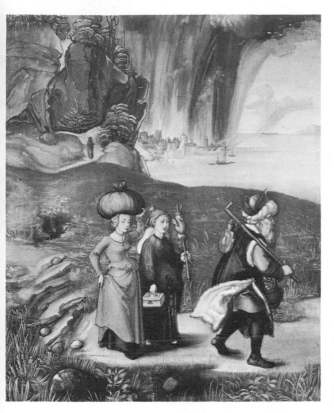

31. Dürer. Lot and His Daughters, showing the destruction of Sodom and Gomorrah in the background. National Gallery of Art, Kress Collection, Washington, D.C.

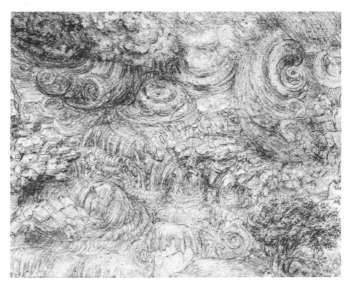

32. Leonardo da Vinci. Destruction of the World. Chalk drawing, c. 1510-15(?). Royal Collection, Windsor Castle.

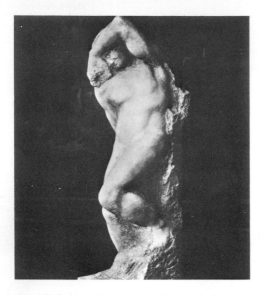

33. Michelangelo. *A Captive. Unfinished figure for the Tomb of Julius II, 1525-30. Accademia delle Belle Arti, Florence.*

34. Michelangelo. *Self-portrait as Nicodemus, detail of the Pietà,* c. 1550. *Duomo, Florence.*

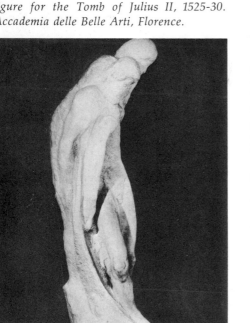

35. Michelangelo. *The Rondanini Pietà. In course of revision at the artist's death in 1564. Museo del Castello Sforzesco, Milan.*

36. Michelangelo. *Heads of the Virgin and Christ and the torso of Christ of the Rondanini Pietà. Detail of Figure 35.*

Index

Index

The index covers text, notes, and appendices. Michelangelo is abbreviated M; Donatello is abbreviated D.

Adam: and M's drawing for the David, 4; Pico's myth of, 51–52

Agostino di Duccio: first carver of M's David, 30, 45; recalled from Bologna to assist D, 35, 36–37; trained under D, 37; marble colossus of 1464 for Duomo (David), 37–38, 41, 127–31, 133, 135; terracotta colossus of 1463 for Duomo, 37, 54, 104, 123–25, 127; mentioned, 137

Alberti, Leone Battista: on design over materials, 34; admiration for colossal mode, 34; on aims of art, 46; modular canon, 50; influence on D, 50, 91 *n*7, fig. 14; inventor of type of running drill, 84 *n*5; date of his *De Statua*, 91 *n*6; mentioned, 40

Ammanati, Bartolommeo, 65

Andrea da Firenze: model of Duomo, 27, fig. 9. *See also* Florence: Duomo, Tribuna-program Antique, the (Greco-Roman): influence on Florentine sculptors, 27; human imagery in, 30; influence on colossal mode, 34–35; influence on M, 46–47, 49–50; influence on statuary placement, 58; and Leonardo's storm-imagery, 74

Antiquity (Greco-Roman): use of running drill in, 7; Vasari on, 25; influence on use of terracotta, 29–30; influence on colossal scale, 33, 104; colossal mode in, 48–49; notions of macrocosm and microcosm inherited from, 50. *See also* Colossus; Etruscans; Pliny; Rome

Antonio di Banco, 109, 111

Antonio di Matteo Gambarelli. *See* Rossellino, Antonio

Apollo: laurel symbolism applied to Lorenzo de' Medici, 6; attributes of, in Colossus of Rhodes, 48; as symbol of justice, 48–49

Arca, Niccolò dell'. *See* Niccolò dell'Arca

Architecture: and Florentine communal liberty, 9, 10, 58

Aretino, Pietro, 71

Armorers' guild. *See* Florence: Armorers' guild

183

Index

Lorenzo de' Medici. *See* Medici, Lorenzo

Louvre. *See* Paris: Louvre

Lucca (city): tradition of *Volto Santo* in, 75

Lucretius: cosmic destruction imagery in his poetry, 73

Ludovico consulted on placement of David, 141

Mallet: as symbol of sculptor's craft, 8

Manfredi, Angelo di Lorenzo, da Poppi: on placement of David, 147, 149, 157 *n28*

Mannerism: and Ammanati's colossus, 65

Marble: material for David, 21; "Man" of, 30; quarried at Carrara for colossus in 1464, 127, 129, 133, 135

Marforio (colossal river-god in Rome), 25

Mark, St. *See* Donatello: St. Mark

Mars, by Sansovino, 65

Marzocco (heraldic lion of Florence), 151, 157 *n29*, fig. 25

Masaccio (Tommaso di Ser Giovanni), Tribute Money: style and sources for meaning, 12–13, 14; ethical content, 55, 86–87 *n10*; theories of meaning discussed, 85–86 *n8*; fig. 6

Matthew, Gospel of: quoted, 86–87 *n10*

Mazzinghi, Jacopo di Ugolino dei (Overseer of Florentine Duomo): commissions colossal marble David in 1464, 127

Medici: patrons of art and learning, 13, 15–16; M's relation to, in youth, 15–16; and in old age, 71–72; returned

to power, 55, 69, 72

— Alessandro: assassinated, 69

— Cosimo: patron of D, 36

— Cosimo I: patron of Vasari, 22, 55–56

— Guilio: proposed a Medici colossus, 71

— Lorenzo (the Magnificent): patron of M, 5–6; art and humanism in court of, 14–16, 88 *n15*

Michelangelo (Buonarroti): personality in poems and letters, 3–4; feelings of identity, 4–5, 7–8, 84–85 *n5*; Medicean patronage of, 5–6, 9, 14, 15–16, 47, 72, 88 *n15*; republican leanings, 9, 10, 16, 55, 60–61, 69, 71–72; family ties, 10; as apprentice, 12; influence of Neoplatonism on, 15–16; preference for whole marble, 23; commission for David, 25–26, 38–39; search for identity as an artist, 40–41, 45–46; influence of Roman sojourn, 46–47; self-portrait as St. Proculus, 53, figs. 16, 19; his David as an Adam, 51–53; and as self-portrait, 54; preference for placement of David, 59, 63, 155; portrayed by Raphael, 66, 69–71, fig. 29; ironic self-portrait, 71, fig. 30; ironic comments on Medici colossus, 71; anti-Medicean feelings, 71–72; pessimism in *non finito*, 74–75; self-portrait as Nicodemus, 75–76, fig. 34; possible self-portrait in Rondanini Pietà, 76–77, figs. 35, 36

— Eros (now lost), 47

— Hercules (now lost), 54, 89 *n11*

— St. Proculus, 53, figs. 16, 19

— David of 1501–04: copy of, in original location, 3–4; drawing for arm of, 4,

190